National Trust
ON SCREEN

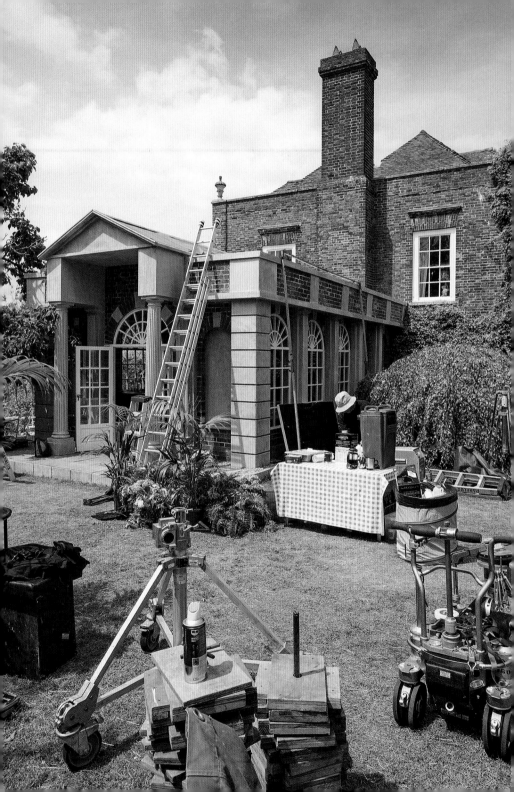

Harvey Edgington and Lauren Taylor

National Trust
ON SCREEN

DISCOVER THE
LOCATIONS
THAT MADE
FILM AND
TV MAGIC

National Trust

Lauren – *For Graeme and Milo*

Harvey – *For Louise, Mathilde and Joe*

First published in the United Kingdom in 2020
This edition published in 2024 by
National Trust Books
An Imprint of HarperCollins Publishers
1 London Bridge Street
London SE1 9GF www.harpercollins.co.uk

HarperCollins Publishers
Macken House, 39/40 Mayor Street Upper,
Dublin 1, D01 C9W8, Ireland

ISBN 978-0-00868-828-8
10 9 8 7 6 5 4 3 2 1

The contents of this publication are believed correct at the time of printing. Nevertheless, the publisher can accept no responsibility for errors or omissions, changes in the detail given or for any expense or loss thereby caused.

A catalogue record for this book is available from the British Library.

Printed and bound in India
Designed by Tokiko Morishima and Ginny Zeal
Edited by David Salmo and Charlotte Mozley

If you would like to comment on any aspect of this book, please contact us at the above address or national.trust@harpercollins.co.uk

National Trust publications are available at National Trust shops or online at nationaltrustbooks.co.uk

NOTE ON THE TEXT
Cross references to National Trust filming locations that have entries in this book are given in **bold**. These can be looked up in the index. Dates in brackets after film and TV titles refer to the year it was released or screened, not when it was filmed.

FRONT COVER TOP: Regé-Jean Page as Simon Basset and Phoebe Dynevor as Daphne Bridgerton in *Bridgerton* at Stowe in Buckinghamshire.
FRONT COVER BOTTOM: Michael Caine as Alfred Pennyworth and Christian Bale as Bruce Wayne in the Entrance Hall of Osterley Park and House in London for *The Dark Knight Rises*.
BACK COVER: Russell Crowe as Robin Hood with director Ridley Scott at Freshwater West in Pembrokeshire.
TITLE PAGE: Filming *Mapp and Lucia* at Lamb House in East Sussex.

Contents

Map of filming locations

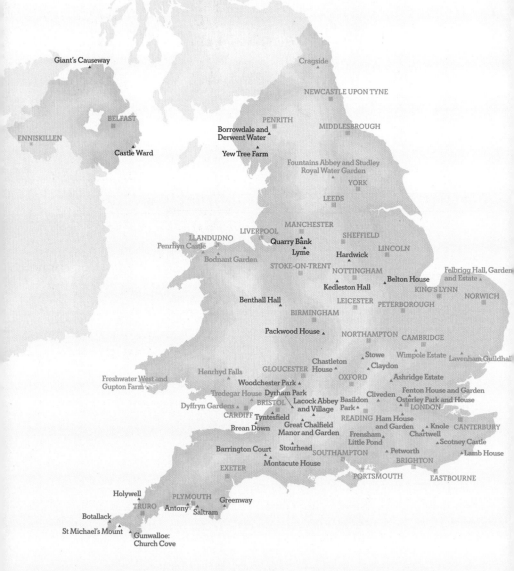

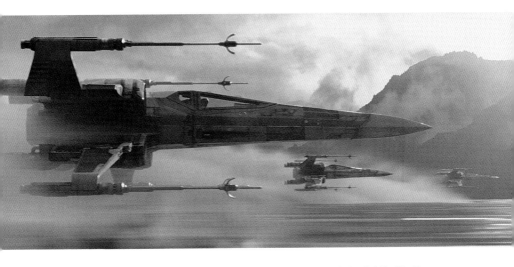

INTRODUCTION

Welcome to this newly revised and updated edition of *National Trust on Screen*. First published in March 2020, just days before the nation went into lockdown as a global pandemic took hold, some of the updates look at how the film industry adapted to these circumstances and how the Trust had to learn new ways of doing an old job. Thankfully, it didn't take long for the productions to find ways to operate within the new rules, as you'll find out when reading about *The Pursuit of Love* and *House of the Dragon*.

Five properties make their debut in this edition: Fenton House and Garden, Penrhyn Castle, Benthall Hall, St Michael's Mount and Scotney Castle. You'll also find new entries covering costume drama sensations *Bridgerton* and *Queen Charlotte: A Bridgerton Story*, as well as thriller *Operation Mincemeat*.

Another significant change that has taken place in the media landscape since this book was first published is the continued rise of streaming services. The need to produce many hours of

on-demand dramas and documentaries has meant that we have never been busier. We're still getting wide-ranging, and occasionally bizarre, queries: can we provide a top-secret military building for the next Bond film? Do we have a spectacular ballroom for next year's big costume drama? Can we build a village on stilts over a lake and burn it down? When the phone rings at the National Trust Filming and Locations Office, it could be any filming query imaginable.

And so a day here is never dull. We might be deep in the detail of planning a shoot – herding the right sort of toads, or working out how exactly an army of six hundred (with 150 horses) will battle their way across a beach. Our small team manages bookings from the initial query right through to the actual shoot days. We sort out the logistics and negotiate every detail, from whether food and drink can be taken into some of our finest staterooms, to where the trucks are going to park.

Wellington boots and a clipboard are always at hand as we might be out having meetings with

National Trust colleagues and the production's location managers on a cliff, down in a cellar or next to a lake. Each month, an average of nine shoots for TV dramas or films will take place at our properties; sometimes three are happening at once. Occasionally there is a rush on at one location: back in 2009 *Robin Hood* immediately followed Harry Potter on Pembrokeshire's Freshwater West beach. They nearly had to wrestle for the dates they wanted.

Since 2003 the Trust has had a dedicated Filming and Locations Office to manage the demand. Filming isn't new to the Trust though: in the 1950s we hosted Cary Grant at Osterley Park in *The Grass is Greener*; the 1960s saw a Carry On film, *Don't Lose Your Head*, at Cliveden, and Harrison Ford popped by Stowe for *Indiana Jones and the Temple of Doom* in the 1980s.

Over the years we have managed to make lots of outlandish-sounding requests work: an entire village was constructed over Frensham Pond for *Snow White and the Huntsman* and then burnt down ten times a night; the entrance to Christopher Nolan's bat cave in *The Dark Knight Rises* was built in the corner of Osterley's Library, and we managed to protect Stowe's Temple of Venus when 170 supporting artists and 400 fireworks arrived for a *Bridgerton* ball.

So why facilitate filming if it's not straightforward? The main reasons are that successful productions often lead to a rise in visitors and in addition to this, being in a film or TV series generates much-needed income for the location, which can be used for conservation work. Great Chalfield Manor re-roofed its stables thanks to *The Other Boleyn Girl*; after Tim Burton's *Alice in Wonderland*, Antony in Cornwall saw its visitor numbers quadruple. Hosting a film can also boost the local economy, as cast and crew need to be accommodated, transported and catered for.

In this book we've gathered all of our most memorable on-screen moments together. Over

the years we've hosted an extraordinary range of productions: we've been Winterfell in *Game of Thrones*; Poldark has picked up shipwrecked goods on one of our beaches; Alice has disappeared down a rabbit hole in our garden and a certain Mr Darcy has taken a dip in one of our lakes – surely costume drama's most iconic moment. Our places have sometimes briefly become far-flung spots around the globe, and beyond: North Korea, California – even a galaxy far, far away in *Star Wars: Episode VII – The Force Awakens*.

Fountains Abbey, Chartwell and Petworth have all 'played themselves', which was less of a stretch for them, but it's not just houses and the countryside that get a look-in: a mine, a mill, an entire village and a holiday cottage have all lent their looks to some high-profile film productions and appear in this book.

We'll reveal which actors have become National Trust regulars, (we're looking at you Judi Dench, Aidan Turner and Keira Knightley); why the sites were chosen, and how we manage the complicated challenges that filming in historic places can present. Whether it's a beach, woodland or a house, we have to ensure the film-makers can achieve the shots they need in locations that must be left as they were found.

It's been a trip down memory lane for us and some surprisingly quirky facts emerged. We'd never thought about what Jonathan Pryce, John Nettles and Johnny Depp have in common: we now know they've all played characters who have died in bedrooms in our houses. Which is unfortunate as we're usually trying to make the room come alive. Donald Sutherland has had two filming stints with us, 38 years apart: in 1967 he was one of *The Dirty Dozen* who stopped by the Ashridge Estate and in 2005 he played Mr Bennet at Basildon Park for *Pride and Prejudice*. We've also realised the Trust must be the owner of the country's most star-struck hut; it's on the Ashridge Estate and is a very well-used location.

The hardest part of producing this book, apart from gluing the pages together, has been selecting which productions to feature. We couldn't put them all in unless we gave away a bookcase with every copy. It was a long debate and in true Hollywood style we now only converse with each other via lawyers. In the end we have selected those that we know there is great interest in (we get the emails), the biggest box office hits, the mightiest action films, and the most compelling and well-loved costume dramas. As well as some personal favourites.

Filming is very much a team effort and collaboration across the Trust often starts months in advance. With contracts exchanged, and all parties fully briefed, the property staff are braced for the arrival of the film crew. The best bit comes much later – sometimes a year or more – in the cinema or on the sofa at home, when we finally see one of 'our' properties appear on screen and can annoy our family by pointing them out.

We take this opportunity to say thank you to all of our colleagues at the National Trust places who work with us and the film crews before and during the shoots. Also to the project conservators and our own in-house conservation filming specialists, all of whom are expert in the supervision of historic location filming and who ensure that our buildings and landscapes are safeguarded. We couldn't function without their knowledge and guidance.

We hope this book becomes a companion on your visits to our houses and landscapes; nowadays you can even download the film and take it with you to stand on the exact spot where the director placed the camera. As good as our places look on film they are even better in real life. You might just bump into one of Hollywood's finest.

We hope you enjoy the book and, as they say, there is always room for another sequel. Happy location hunting!

Harvey and Lauren

BELOW Cate Blanchett as Elizabeth I at Brean Down during the filming of *Elizabeth: The Golden Age* (see page 31).

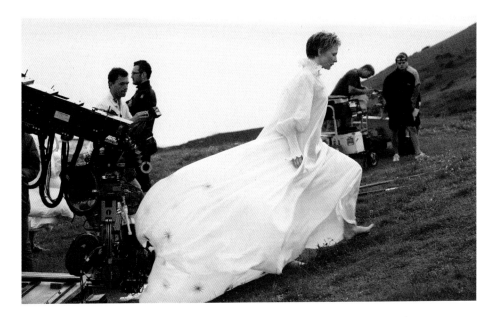

9

BOTALLACK
ON THE TIN COAST, NEAR ST JUST, CORNWALL

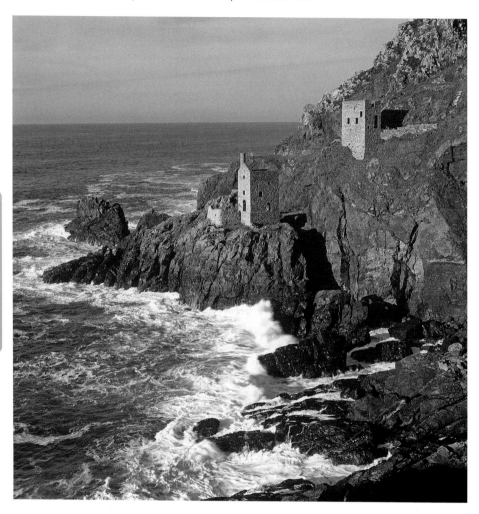

Botallack is part of the Cornwall and West Devon Mining Landscape UNESCO World Heritage Site and sits on the South West Coast Path. The abandoned mines now serve as a reminder of the area's once prosperous past when mines stretched out half a mile under the sea bed and produced thousands of tons of copper and tin every year. At one point there were over a hundred engine houses in the St Just area. Botallack has been closed for over a century.

RIGHT **Ross Poldark (Aidan Turner) and Francis Poldark (Kyle Soller) at Wheal Owles.**

Poldark (2015–2019) 📺

Directed by various; starring Aidan Turner, Eleanor Tomlinson, Kyle Soller, Luke Norris

The buildings at Botallack stood in for various Poldark family mines in all five series of the BBC's hit adaptation of Winston Graham's novels. At the beginning of series one Ross Poldark, played by Aidan Turner, returns to Cornwall after fighting in the American War of Independence. It's a far from rosy homecoming as he finds out that his father is dead, his mines and home are in disarray and his first love Elizabeth is engaged to his cousin. Cornwall's dramatic coastline, countryside and mines, many of them National Trust-owned, provided awe-inspiring backdrops for the action.

The Wheal Crowns buildings (shown opposite), perched on jagged rocks right next to the sea, were used as Francis Poldark's failing 'Wheal Grambler' in series one. The buildings at Wheal Owles, situated on the headland, played Ross Poldark's resurrected mine 'Wheal Leisure'. Wheal Owles provided the setting for both Wheal Leisure and then 'Wheal Grace', having been cleverly adapted by the art department to look like different places; it continued as Wheal Grace throughout the remaining series. In the very final episodes, the mine at Wheal Coates near St Agnes, around 35 miles from Botallack, became the derelict Wheal Leisure. Wheal Coates overlooks a rather lovely wide expanse of sand at Chapel Porth beach.

For each series of *Poldark*, the art department would spend a week or more taking the Botallack mines back the required two hundred years. If there was a National Trust award for the most used location for one TV series, this would surely win. Due to Botallack's World Heritage status the parameters at all these mines had to be tight: nothing could be attached or fixed to the

CORNWALL

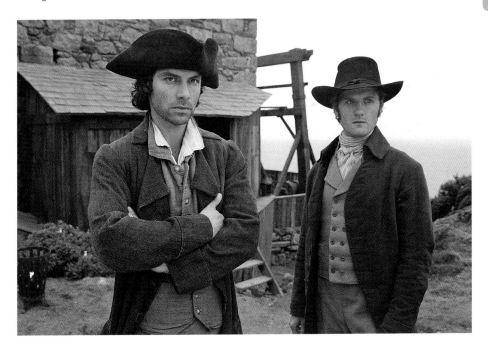

buildings, so anything added had to be built around or placed on the building. The set-building work included sheds, outbuildings and a scaffold platform inside the mine shaft. This provided a raised floor level so the actors would be able to come and go from the building. Shutters and doors had to be carefully wedged into the lower windows and doorways; when removed they left no trace of ever having been there.

Filming in such an exposed area has its challenges. During the second series, gale force winds of up to 80mph damaged much of the set and it had to be re-built. Location manager, Poppy Gordon Clark, described the wind as '. . .dangerous. We could barely stand up and there was wood from the set flying everywhere. The set had to be stood down and re-built before we could return.' There was an upside, as Poppy explained, 'We had to find somewhere to film when it was being re-built so I asked the National Trust if I could take the crew to nearby Porthcurno beach. We went and it made a lovely backdrop for a Ross and Demelza dream sequence.' Every windy cloud has a silver lining.

Only fairly minimal additions were made to the Wheal Crowns buildings, and the mine works above them were put in later by the visual effects team. On shooting days, it would have been a bustling scene with up to 75 film crew, ten actors and around thirty supporting artists. Anyone passing by had the chance to see how the mines and their surroundings would have looked in their heyday. The mine interiors weren't filmed here because of safety issues. Instead filming was done in the Poldark Mine nearby or in the Redcliffe caves in Bristol.

The National Trust is sad to report that Ross Poldark's scything scene did not take place on its land. Admirers were thrilled to see ancient farming methods brought back to life and wondered when Ross would next need to deal with an overgrown meadow. The scene was actually filmed in a cornfield above Porthcothan beach on the north Cornish coast near Padstow.

For more on *Poldark*, see the entries for **Holywell**, **Gunwalloe: Church Cove** and **Great Chalfield Manor and Garden**.

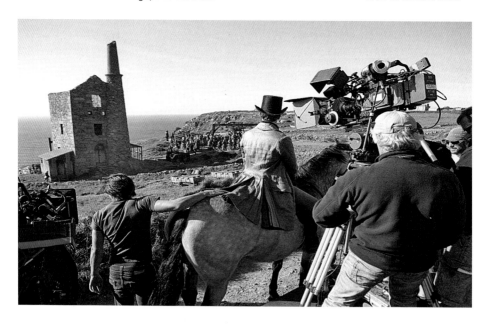

BELOW Francis Poldark (Kyle Soller) and the crew at Wheal Owles.

ST MICHAEL'S MOUNT

MARAZION, CORNWALL, TR17 0EG

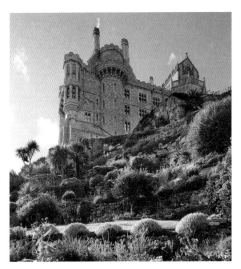

St Michael's Mount is linked to the mainland town of Marazion by an ancient causeway or by ferry boat, depending on the tide. This majestic island castle, centred around a monastic chapel and dating back to the twelfth century, has been home to generations of the St Aubyn family, who still live there today. Subtropical terraced gardens cling to the steep granite rock face below, and the harbour and village continues to be the hub of island life. The Mount is managed in partnership between the St Aubyn family and the National Trust.

House of the Dragon (2022–) 📺
Directed by various; starring Matt Smith, Paddy Considine, Milly Alcock

Following the global success of *Game of Thrones*, it was as sure as night follows day that there would be a sequel or prequel. *House of the Dragon* takes the saga back nearly 200 years. Still based on the novels of George R.R. Martin, the new show portrays the decline of

the House of Targaryen in a war of succession known as the Dance of the Dragons.

A new show meant a new location base. *Game of Thrones* was based in Northern Ireland but *House of the Dragon* headed in part to Cornwall, an area, like everywhere at the time, that was suffering under the pandemic. It was a welcome boost to the local economy. St Michael's Mount was the scene of a dramatic funeral at the 'boiling cauldron' and wake, plus some characters arriving by boat to the delightful harbour on the mount. No interiors were required, but sets were assembled in the courtyard. Plinths and a sarcophagus were added, along with a mound of mussels made of plastic to avoid cross contamination within the local eco system.

With electricity not existing in the fantasy world, there were a lot of naked flames in braziers and torches all adding to the atmosphere. Boats sailing into the harbour and vehicles crossing the causeway were added with the magic of computers. The show stars Matt Smith as the devious Prince Daemon Targaryen, Paddy Considine as his father and Olivia Cooke, from a rival family, as Queen Hightower. For series two, as far as the National Trust was involved, the show had moved on again, this time to Wales.

For more on *House of the Dragon*, see the entry for **Holywell**.

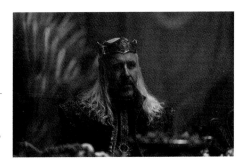

ABOVE **Paddy Considine as King Viserys Targaryen.**

CORNWALL

HOLYWELL

NEAR NEWQUAY, CORNWALL

CORNWALL

Holywell is a large sandy beach which takes its name from a holy well in one of its caves. Spectacular grassy sand dunes rise to nearly 20 metres (65 feet) in places and there are also ancient signs of habitation from both the iron and bronze ages.

BELOW Building the set on and around the lifeguard building.

OPPOSITE The completed set.

Die Another Day (2002) 🎥◄

Directed by Lee Tamahori; starring Pierce Brosnan, Halle Berry, Toby Stephens

The beach is a popular surfing location – appropriate given that the opening sequence of *Die Another Day* features our Mr Bond surfing onto the beach. However, Holywell beach was supposed to be North Korea and the actual surfing was shot in Hawaii.

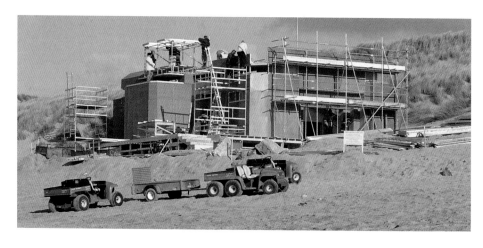

RIGHT Demelza Poldark (Eleanor Tomlinson) at Holywell.

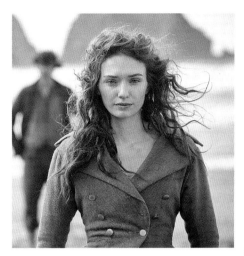

Bond is betrayed and then captured by the North Koreans, eventually being released in a prisoner exchange. The drama hinges on his revenge as he seeks out the mole who betrayed him. He still makes time for the charms of NSA agent Jinx Johnson, played by Halle Berry, and MI6 agent Miranda Frost (Rosamund Pike) and fits some killing and blowing things up into his busy schedule. Madonna gives fencing lessons to the under-cover agent who uses his real name.

Although Bond movies are often filmed in glamorous overseas locations, suitable UK sites are used if they can be made to look more exotic. Replicating North Korea took four weeks of set-building. An estimated £500,000 was spent locally on materials, hotels and food. The exterior of a 'top secret military installation' was built on top of the existing lifeguard building. Tank traps were added on the beach and a smattering of soldiers completed the illusion. The action sequences that take place inside the building were shot in a studio. The final sequence in the film, still set in North Korea, was shot at another National Trust beach, Penbryn in Wales.

For more on James Bond films, see the entry on **Stowe**.

Poldark (2015–2019) 📺
Directed by various; starring Aidan Turner, Eleanor Tomlinson, Harry Richardson, Ellise Chappell

Like **Church Cove** on the Lizard Peninsula, Holywell became one of the beaches on Ross Poldark's estate, Nampara. Supposedly right next to each other, Church Cove and Holywell are actually 30 miles apart. Holywell was used for all sorts of scenes in series two to five, including one of Ross's swims, Caroline and Dwight's galloping horse-ride and the meetings between Drake and Morwenna. The distinctive offshore islands known as Carter's and Gulls Rocks make it an easily identifiable location.

The film crew could drive vehicles directly onto the beach here which saved them time as their equipment would be to hand. One slight drawback however was that their 4x4s often got stuck in the sand. The location manager addressed this sinking problem by having a tractor on stand-by which '...pulls everyone out every ten minutes'. The beach at Holywell is vast and easily accommodated cast, crew, equipment, vehicles and any visitors simultaneously.

For more on *Poldark*, see the entries for **Botallack**, **Gunwalloe: Church Cove** and **Great Chalfield Manor and Garden**.

CORNWALL

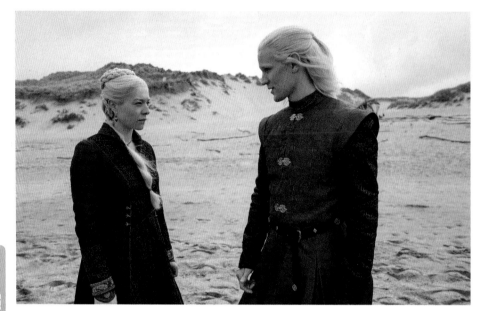

House of the Dragon (2022–) 📺
Directed by various; starring Matt Smith, Paddy Considine, Emma D'Arcy

If there was one thing *Game of Thrones* was famous for other than dragons, it was battle scenes. Often taking weeks to film, they were usually a chance for characters to shine or alternatively, err ... die. *House of the Dragon* would follow suit. However, on Holywell it would be the aftermath of a battle that was required. Dead bodies, small fires, discarded swords, washed-up boats, etc. In fact, a right old mess. This was all enhanced with wind machines and smoke, plus main characters discussing events and perhaps asking who was going to clear it all up.

Off screen was a further consideration about actual litter, this time PPE. All was double bagged to avoid contamination and the production had a Covid Coordinator to prevent the crew getting lax about the regulations. An ecology report was prepared and seaweed sourced locally then moved up the beach to avoid cross-contamination. Five other local organisations, including the Parish Council and RNLI, had to be kept informed of the filming. Normal daily life must continue,

whatever mythical warring dynasties might be doing.

For more on *House of the Dragon*, see the entry for **St Michael's Mount**.

TOP Prince Daemon Targaryen (Matt Smith) and Queen Rhaenyra Targaryen (Emma D'Arcy) discuss the carnage.

ABOVE Locals studiously ignore multi-million-pound TV production.

GUNWALLOE: CHURCH COVE

NEAR HELSTON, CORNWALL

Church Cove is a sandy south-west facing bay on the Lizard Peninsula. The medieval church of St Winwaloe sits to its north side and is the only Cornish church situated on a beach itself. The area is well known for shipwrecks; adjacent Dollar Cove is so-called after a Spanish ship which sunk in 1669 with a cargo of silver dollars. You might want to take a snorkel.

Poldark (2015–2019) 📺
Directed by various; starring Aidan Turner, Eleanor Tomlinson, Gabriella Wilde, Luke Norris

The beach was chosen to play 'Hendrawna beach', part of Ross Poldark's Nampara estate in series one, two and five. Aptly enough, a dramatic night-time shipwreck scene was filmed here for series one. Filming took place over two nights, beginning at dusk and going on until dawn; a 5am finish allowed them to capture a magical sunrise shot.

One day's prep involved setting up special effects fires that were dotted about the beach. For conservation and safety reasons, the fires were set in metal bases to keep them from contact with the sand. A fire officer was on stand-by as they always need to be when any sort of flame is involved. Lighting was placed either side of the cove on the headland to create the atmospheric look for what would be a tense piece of action.

If St Winwaloe church (not National Trust) looks familiar then you're right, it was the setting for the wedding of Caroline Penvenen and Dwight Enys at the start of series three.

Also on the Lizard Peninsula lies Kynance Cove. The beach is seen in series two when a pregnant Demelza is out fishing for pilchards and goes into labour.

For more on *Poldark*, see the entries for **Botallack**, **Holywell** and **Great Chalfield Manor and Garden**.

Also filmed at Gunwalloe: Church Cove: *Doc Martin* (TV, 2004–2022)

17

ANTONY

TORPOINT, CORNWALL, PL11 2QA

A beautiful early Georgian house overlooking the River Lynher in Cornwall, Antony has long been home to the Carew Pole family. A portrait of Rachel Carew is said to have inspired Daphne du Maurier's novel *My Cousin Rachel*. The garden is the creation of Georgian landscape designer Humphry Repton.

ABOVE Alice (Mia Wasikowska) looks down the rabbit hole.

Alice in Wonderland (2010) 🎥

Directed by Tim Burton; starring Mia Wasikowska, Johnny Depp, Anne Hathaway

It was the garden that struck director Tim Burton as the best place to stage the open-air party where Alice is supposed to be married off to a buffoon. Instead, she runs away and begins her adventures. One of only two 'live' locations in the film, the interiors of the house were also used as Alice's home. All of the supporting artists were recruited locally with a massive audition held in a local hotel.

A bandstand was built, and in the film an intricate dance is performed, accompanied by a live band playing music from the Edwardian period. All of the flowers were carefully replaced with white roses and a blue bag representing the White Rabbit was dragged through the garden. The actual rabbit was added later with visual effects.

Luckily for the film crew, the weather was glorious which had not been the case in the planning stages; the area eventually used for parking was initially inches deep in rain water.

Rumours swirled excitedly around social media that Johnny Depp would be on set, along with Anne Hathaway and Helena Bonham Carter. However, the characters they played were ones that Alice meets after she has gone down the rabbit hole (cleverly built in the grounds at Antony), and thus would all be filmed in the studio. Mia Wasikowska as Alice was on location, however, along with British stalwarts Frances de la Tour, Lindsay Duncan and Tim Pigott-Smith.

The house and the family had never hosted a film shoot before so there was a steep learning curve which happily everyone embraced. Their reward after the film's release was an almost quadruple increase in visitor numbers, partly helped by Tim Burton enthusiastically talking about Antony at press conferences.

Of course, the spike in visitors had to be planned for – and not just in terms of catering and parking. Fortunately, the film being so heavy with visual effects, its release came almost 18 months after the shoot, and the house was able to arrange Alice-themed activities for that summer: a theatre group enacting the Alice story, and a two-storey clock for those who, like the White Rabbit,

didn't want to be late. Many of the new visits were due to the 'pester power' of children making their parents take them to Antony.

The only other real location was Charlestown (not National Trust), the historic harbour in Cornwall, used for the scene where Alice sets off to travel the world.

Despite the film taking over $1 billion in revenue, Tim Burton did not direct its sequel and thus Antony was not used again.

CORNWALL

ABOVE Alice (Mia Wasikowska) on set.

RIGHT Tim Burton between takes.

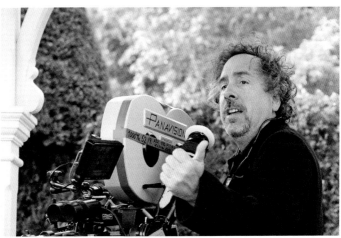

GREENWAY

GREENWAY ROAD, GALMPTON, NEAR BRIXHAM, DEVON, TQ5 0ES

Greenway was the holiday home of the world's best-selling novelist Agatha Christie. The house is displayed as it was in the 1950s and was where the family would spend relaxing summers and Christmases with their friends. Its spectacular garden leads down to the River Dart and the boathouse where Christie set the murder scene in her novel *Dead Man's Folly*.

ABOVE David Suchet being protected from the elements.

Poirot (Series 13, 2013) 📺
Directed by Tom Vaughan; starring David Suchet, Sean Pertwee, Zoë Wanamaker

In the plot of 'Dead Man's Folly' Sir George and Lady Stubbs host a village fête and stage a mock murder mystery which unfortunately turns into the real thing. In the novel the murder takes place at Nasse House, which Christie based on Greenway. So, it was fitting that when Agatha Christie Limited and ITV Studios came to shoot the final episode of *Poirot* – the last of the 70 produced between 1989 and 2013 – they asked if it could be at

Greenway. The National Trust was delighted to be part of TV history. David Suchet had played Poirot throughout and the final shot would be of him walking into Greenway. This was followed by an emotional off-screen party on the lawn for cast and crew.

Visitors to the house on that day were allowed to watch the shoot and mingle with the crew. Actors, in costume and make-up and often staying in character, chatted to the public between scenes.

National Trust properties feature in other episodes of the series; Nuffield Place and Hughenden are in 'The Big Four' and Greys Court appears in 'Elephants Can Remember'.

Poirot is one of the big and small screen's recurring characters, having been played by at least 12 other actors, including in recent years, Kenneth Branagh. Poirot has even featured in a Japanese anime cartoon. However, nobody has played him so often or for so long as David Suchet. Indeed he returned to Greenway to make a documentary about that very subject. It was called *Being Poirot*.

Christie's popularity is worldwide and her books have been translated into 103 languages. Her sales continue to grow, particularly in India, and there have been approximately 190 TV or film adaptations of her work with, no doubt, more to come. Interest in Greenway is also international and the house is tailored for visitors wanting to experience a slice of her life.

With the help of the Filming and Locations Office, Greenway hosted a Christmas Agatha Christie film festival, the first one being curated by Christie's grandson Mathew Prichard. It reflected how the style of the screen adaptations have changed over the years, ranging from 1960s mind games to traditional drawing-room mystery solving and even to a touch of Scandi-noir.

> **“** *I loved filming at Greenway because it took me right back to 1987 when I first met the Christie family and they invited me down to Greenway. That was my first visit to the house. Having the opportunity to film at Greenway was truly wonderful and a memory I will cherish.* **”**

David Suchet

ABOVE David Suchet outside the front of the house.

LEFT Cast and crew working down at the property's battery.

SALTRAM

PLYMPTON, PLYMOUTH, DEVON, PL7 1UH

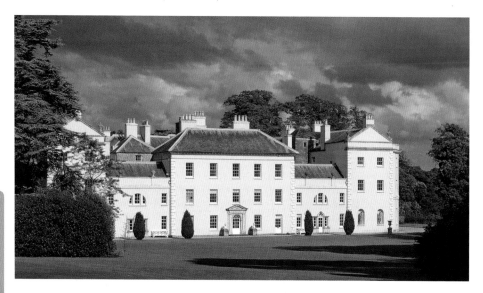

Saltram once stood in open countryside; nowadays the suburbs of Plymouth have reached the boundaries of the estate. An elegant eighteenth-century country house built around an earlier core, its magnificent interiors include a suite of rooms by master architect and designer Robert Adam.

Sense and Sensibility (1995) 🎬

Directed by Ang Lee; starring Emma Thompson, Kate Winslet, Hugh Grant, Alan Rickman

In *Sense and Sensibility* Norland Park is the house no one wants to leave – no wonder Saltram was chosen for the part. Emma Thompson won an Oscar for her adaptation and also starred as Elinor Dashwood, alongside Kate Winslet as her less sensible sister, Marianne. Forced to leave their beloved home due to those pesky nineteenth-century laws forbidding women to inherit property, they decamp to a cottage in Devon. The upside to all this is that, along the way, they do make many favourable new acquaintances.

The first half hour of the film takes place at Saltram, and the Saloon, Library, Entrance Hall, Mirror Room, Staircase and Stables all make an appearance. The sisters' first encounter with Hugh Grant's impeccably mannered and handsome Edward Ferrars takes place in the Saloon. This beautiful pastel-coloured room is Robert Adam's handiwork; he designed every single aspect, from the door handles to the carpet pattern which echoes that of the ornate ceiling.

During a scene in the Library, Margaret, the youngest Dashwood sister, takes refuge under a table while Edward and Elinor pretend not to notice. Her character also liked hiding in a treehouse so a rather elaborate one was constructed in the grounds.

Other National Trust properties appear in the film. **Montacute House** later appears as Cleveland, where Marianne gets caught in the rain and becomes dangerously ill. Mompesson House's exterior, Entrance Hall and Staircase play Mrs Jennings's London town house. In the 2008 TV version, **Ham House** and its garden becomes Cleveland, while **Dyrham Park** plays Allenham. Do keep up.

BELOW Hugh Grant under attack by the youngest
Dashwood sister in the Saltram grounds.

BOTTOM Emma Thompson as Elinor, Kate Winslet as
Marianne and Gemma Jones as Mrs Dashwood.

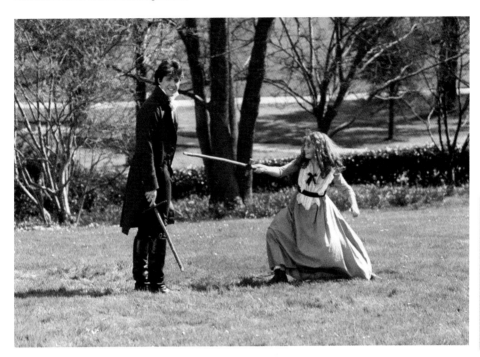

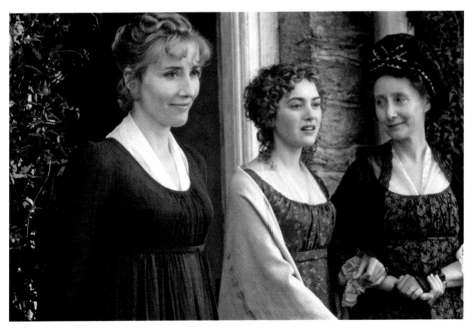

DEVON

MONTACUTE HOUSE
MONTACUTE, SOMERSET, TA15 6XP

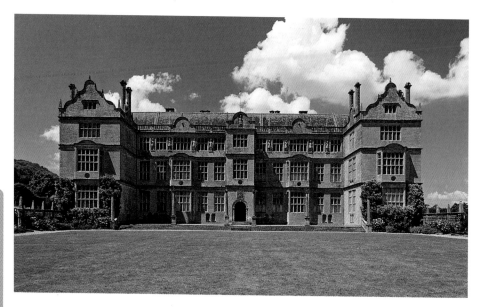

Montacute House was built at the end of the sixteenth century for Sir Edward Phelips, lawyer and Speaker of the House of Commons. The Long Gallery is the longest surviving Elizabethan gallery in England at 52 metres (170 feet). On display on the middle floor is an important collection of sixteenth and early seventeenth-century portraits from the National Portrait Gallery.

Wolf Hall (2015) 📺
Directed by Peter Kosminsky; starring Mark Rylance, Damian Lewis, Claire Foy, Jonathan Pryce

Tudor intrigue abounds in this six-part drama based on Hilary Mantel's best-selling novels *Wolf Hall* and *Bring Up the Bodies*. The award-winning series covers the life of arch-schemer Thomas Cromwell, played by Mark Rylance. Cromwell was advisor to Henry VIII, played by Damian Lewis, and instigator of inventive ways of ending his first two marriages. National Trust properties

made up 40 per cent of the locations used in *Wolf Hall*.

Montacute House is the first building seen in the opening moments of episode one, 'Three Card Trick'. The Dukes of Norfolk and Suffolk are seen making a thundering horseback arrival at 'York Place', along Montacute's West Drive. Dusk makes it all rather ominous. They've come to tell Cardinal Wolsey his days as Lord Chancellor are over. In the next minute and a half of film, a total of five locations were knitted together to make up this arrival. **Chastleton House** is the first interior shot as Cromwell notes their arrival from an upstairs window in the Long Gallery. Action then cuts to the riders entering the courtyard of Sherborne School (not National Trust) before tracking Cromwell down a corridor at Caerphilly Castle (not National Trust). The dukes then enter the Long Gallery at Penshurst Place (not National Trust) where they demand Wolsey hand over the seal of office. On Cromwell's advice Wolsey tells them they can only hand the seal to the Master of the Robes so they'll need to come back with

him. They're furious – as well they might be having come to London via Somerset, Dorset and Kent.

Aside from the opener, Montacute House played a key role in *Wolf Hall* as both interiors and exteriors of Greenwich Palace. The palace was Henry VIII's main London home so the location chosen had to be suitably opulent. Two weeks of filming took the crew all over Montacute; they used – deep breath – the Screens Passage, Great Hall, Dining Room, Parlour, Parlour Passage, Hall Chamber, Library Lobby, Library, Crimson Bedroom, Crimson Bedroom Dressing Room, Oak Parlour, Curzon Room, Office Lobby, and outside the North Garden, the East Court and the parkland. This all translated to scenes in episodes two, four, five and six. Henry had a bad dream in the Crimson Bedroom, the same room that Johnny Depp died in when he played

John Wilmot, 2nd Earl of Rochester in *The Libertine* (2004). Please do not blame the furnishings.

Archery scenes with the king, Cromwell and members of the court took place in the East Court part of the garden and a tilt-yard for jousting was built on the parkland. This was a big build and required tents, where Tudor participants would have changed before entering the joust, as well as viewing

BELOW **The crew prepare for shots in the Great Hall. Director Peter Kosminsky stands far right.**

RIGHT **Hand-held cameras gave the drama a documentary feel.**

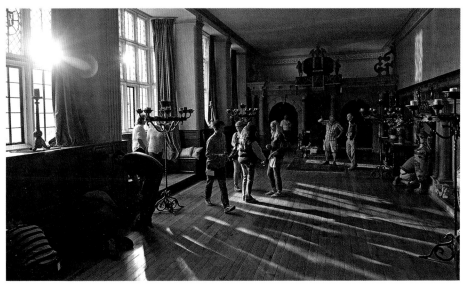

platforms for the king and queen. A carpentry and joinery tent was set up in the parkland and three of the construction team worked away continuously for around two weeks. This is the scene where the king gets knocked off his horse and it looks unlikely he will survive. Many historians believe this was when his physical decline began.

Tree-guards aren't very Tudor and the ten that would be in-shot were removed by the National Trust ranger just before filming began and put back as soon as it was over. The sheep were moved out of the field to protect the set and the temporarily un-guarded trees from any nibbles.

For more on *Wolf Hall*, see the entries for **Great Chalfield Manor and Garden**, **Chastleton House**, **Barrington Court** and **Lacock Abbey**.

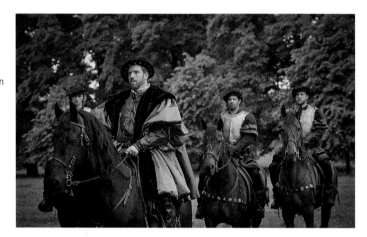

RIGHT King Henry VIII (Damian Lewis) on horseback in Montacute's parkland.

BELOW Henry's office in between takes, set up in the Dining Room. The tapestry was covered between takes to protect it from light damage.

Sense and Sensibility (1995)
Directed by Ang Lee; starring Emma Thompson, Kate Winslet, Hugh Grant, Alan Rickman

Saltram, playing Norland, may have been the star location of this film but Montacute House had an important supporting role as Cleveland, the country home of the Palmers, played by Imelda Staunton and Hugh Laurie. It is here that Marianne (Kate Winslet), falls ill after walking in the rain and where she is nursed back to health. As in *Wolf Hall*, the film-makers included a shot of the picturesque West Drive, this time for a rather more sedate arrival in a carriage. The wibbly-wobbly hedge in the North Garden (also featured in *Wolf Hall*) is seen when Marianne sets out for her walk. The hedge has had this distinctive look since the winter of 1947 when very heavy snowfall meant that it didn't regain its previous neat outline.

Marianne carries on walking into the East Court part of the garden (where *Wolf Hall's* archery took place). The rain machines were out in force to ensure a suitable level of drenching. You see the Great Hall when Colonel Brandon carries Marianne into the house in his arms and Montacute village makes a cameo appearance during the opening credits when John Dashwood and his wife are seen exiting The Phelips Arms, a pub in the village.

Montacute House was also the inspiration for Tottington Hall, the setting of an annual giant vegetable competition in the Oscar-winning Wallace and Gromit film, *The Curse of the Were Rabbit* (2005). There was no actual filming on site but the house was measured and photographed, and the film's animators created a version of the building that's easily recognisable as Montacute.

BELOW Elinor and Marianne arrive at Cleveland.

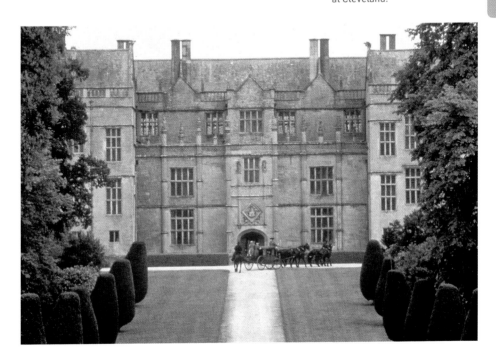

SOMERSET

27

BARRINGTON COURT

BARRINGTON, NEAR ILMINSTER, SOMERSET, TA19 0NQ

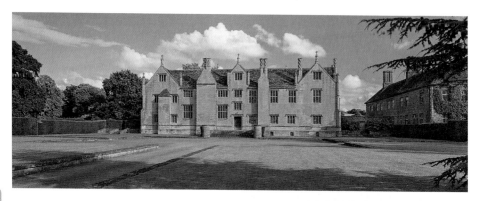

Tudor manor house Barrington Court was restored in the 1920s by Colonel Lyle, of Tate and Lyle sugar fame. Lyle filled the house with panelling, fireplaces and staircases often salvaged from other houses. The house is now entirely empty of furniture. As well as the restored Kitchen Garden, there is a walled White Garden and Rose Garden influenced by Gertrude Jekyll.

Wolf Hall (2015) 📺
Directed by Peter Kosminsky; starring Mark Rylance, Damian Lewis, Claire Foy, Jonathan Pryce

Being devoid of furniture Barrington was ideal for *Wolf Hall* as the crew looked to create York Place, Whitehall, the home of Cromwell's mentor Cardinal Wolsey (Jonathan Pryce). It was also used for scenes at Leicester Abbey while its exterior was Harry Percy's house and Windsor Great Park.

Some alterations were required, such as the removal of modern lighting, and Barrington's delicate staircase was propped up due to concerns about load-bearing. The chimneys also needed surveying and cleaning before special-effects fires could be lit as they can still produce heat and smoke. The crew had to bring in all their own furniture, including

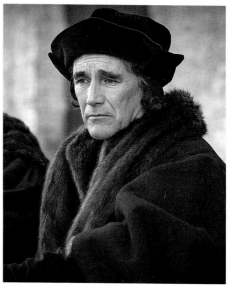

ABOVE Thomas Cromwell (Mark Rylance) looking pensive and troubled.

a deathbed for Wolsey. The distinctive calf pens in the Stables were seen when Thomas Cranmer and Thomas Cromwell wandered in for a chat. Barrington Court followed up the filming with a Wolf Hall costume exhibition.

For more on *Wolf Hall*, see the entries for **Great Chalfield Manor and Garden**, **Chastleton House**, **Montacute House** and **Lacock Abbey**.

TYNTESFIELD

WRAXALL, BRISTOL, NORTH SOMERSET, BS48 1NX

In the 1860s William Gibbs spent some of his fortune made from fertiliser remodelling the exterior of a simple Georgian house into a Victorian Gothic masterpiece. He hired the finest craftsmen in the country to decorate and furnish the house and to build a magnificent family chapel.

When word leaked out, as it inevitably does, that the episode 'The Abominable Bride', was being filmed at Tyntesfield and actors in Victorian costumes had been spied, cyberspace went frantic. Time warps and dream sequences were some of the theories being bandied about.

Tyntesfield would be the Carmichaels' house in the episode. The Carmichaels are being threatened by Emelia Ricoletti even though she apparently killed herself in public after murdering her husband months before. Holmes and Watson investigate.

Almost every part of Tyntesfield's show rooms made up the Carmichaels' house. Naturally its exteriors were also used as they represent Victorian Gothic that money can't buy these days.

Before the shoot the National Trust removed chairs, curtains, mirrors, statues, cabinets and tables. Some were removed for conservation reasons and some were replaced with props that fitted into the production designer's plans. The house staff were asked if the billiard table could be moved but as it is,

Sherlock (Series 4, 2016) 📺
Directed by various; starring Benedict Cumberbatch, Martin Freeman, Tim McInnerny

The BBC revival of Sherlock Holmes was one of the TV successes of the decade. Not only a ratings smash, *Sherlock* was critically acclaimed and attracted a devoted, dedicated following. However, a major part of its success was setting Holmes in the modern day. There are mobile phones, car chases, helicopters and Holmes acting like a smarter version of James Bond.

ABOVE Sherlock (Benedict Cumberbatch) between takes.

strangely, an integral part of the heating system they had to turn down this request.

In recent years the 'balloon light' has changed filming in heritage buildings. Used on this shoot, it involves lights being placed in a helium balloon which is tethered to the floor with ropes and sandbags. The effect is of an even spread of light. Before this technique, lighting from above required scaffolding, often with fake columns being used to hide any metal poles that would be in shot. Bringing in scaffolding poles is inherently risky; it also takes time.

The Emmy Award-winning episode of *Sherlock* was shown on New Year's Day 2016 and it attracted 11 million TV viewers plus those watching in cinemas where it was simultaneously shown. It was then broadcast across Europe and shown in cinemas in South Korea and China. Tyntesfield thus had a genuinely worldwide audience thanks to being inside the part of the brain that Sherlock calls his 'Mind Palace', which is where the whole episode had taken place.

Doctor Who (Series 7, 2013) 📺
Directed by Jamie Payne; starring Matt Smith, Jessica Raine, Jenna Coleman

The Doctor is in 1974 for this episode called 'Hide' and Tyntesfield is a haunted mansion. However, the ghost turns out to be another time traveller stuck in a pocket universe. Apparently this is a bad thing and the Doctor attempts a rescue only to become trapped as well. Writer Neil Cross was keen to make a scary, haunted house episode.

Tyntesfield's famous Gothic interiors were ideal for the mood of the show. National Trust staff were disappointed the Tardis wasn't on location thus spoiling a lot of selfie opportunities. Filming took three days and made use of most of the house.

The episode went out as part of the fiftieth anniversary of the show and Tyntesfield joined in the fun by having a Doctor Who lookalike wandering around the house for a weekend.

Also filmed at Tyntesfield: *Dracula* (TV, 2006), *Doctor Thorne* (TV, 2016)

ABOVE Creating the right atmosphere for the *Sherlock* night shoot at Tyntesfield.

BREAN DOWN
NEAR WESTON-SUPER-MARE, NORTH SOMERSET

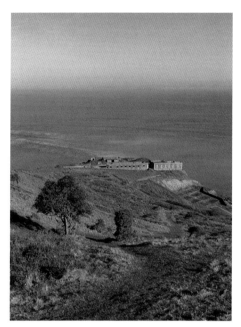

Like most costume dramas based on real events, it is not historically accurate and neither was it shot in the true locations. Brean Down is standing in for Tilbury, Essex. It offered a clear skyline and views across the sea from most angles although the camera skilfully avoids Weston-Super-Mare. Tudor-style tents were required and because the site is of archaeological interest these had to be free-standing and not pegged to avoid damaging anything as yet undiscovered underground. Two-hundred-and-fifty supporting artists were recruited locally for the two-day shoot.

One scene of the queen horse-riding with Raleigh was shot at **Petworth**.

" Let them come with the armies of hell; they will not pass! "

Elizabeth addressing her troops at Tilbury

The site of a Roman fort, Brean Down reaches 97 metres (318 feet) high and offers stunning views over the Bristol Channel towards south Wales as well as the Somerset Levels.

Elizabeth: The Golden Age (2007) 🎥
Directed by Shekhar Kapur; starring Cate Blanchett, Clive Owen, Geoffrey Rush

It was the view that made Brean Down an ideal place for Queen Elizabeth I to address her troops. In the film Cate Blanchett reprises the role she played in *Elizabeth* in 1998. The queen is facing a threat from the Catholic King Philip of Spain. While fighting for her country she must resist her suitor, the puddle-phobic adventurer Sir Walter Raleigh, and the scheming Sir Francis Walsingham who wishes to marry her off. There is also Mary, Queen of Scots to contend with.

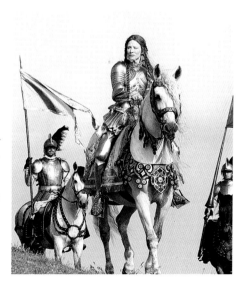

ABOVE Cate Blanchett as Queen Elizabeth I.

SOMERSET

31

GREAT CHALFIELD MANOR AND GARDEN

NEAR MELKSHAM, WILTSHIRE, SN12 8NH

WILTSHIRE

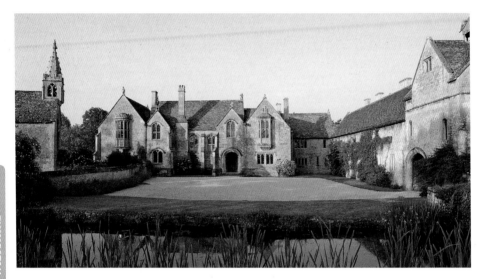

This impossibly romantic fifteenth-century manor house sits in quiet, unspoilt Wiltshire countryside. It's one of the few houses of the period with a largely unaltered exterior and interior, hence its popularity with Tudor era productions. The Arts and Crafts garden, ponds and adjacent All Saints parish church all make for a delightful combination.

Poldark (2015–2019) 📺
Directed by various; starring Aidan Turner, John Nettles, Gabriella Wilde, Luke Norris

The BBC had a huge hit on their hands when Ross Poldark and his scar hit the small screen in March 2015. The epic Cornish saga was filmed mostly where it's set but some of the filming that didn't require coastline and headlands was shot near to the Bristol studios where the production was based.

Great Chalfield Manor doubles as Killewarren, the home of wealthy Ray Penvenen and his niece, Caroline. Ray

Penvenen was played by John Nettles, which no doubt pleased Bergerac fans. The show's location manager David Johnson explained that he was looking for a house that wasn't contemporary to the 1790s but one that implied '. . . old money . . . a house that the Penvenen family would have had for at least 150 years. Great Chalfield was perfect.'

The house appeared in series two, three, four and five and the team made use of much of the house and its grounds on their various visits. The Great Hall shone when it provided the backdrop to a dinner party scene in series two. All the main characters were gathered together, including Ross, Demelza, Ross's cousin Francis and his wife Elizabeth. Twenty supporting artists joined them.

Greenery and food were laid down the table, which was protected by a false top, and candles on candelabra were dotted around the room. The candelabra stood on plastic disks to protect the floor from drips. Outside was looking particularly pretty as eight gas-fed special effects braziers were lit to show guests the way in. The Dining Room, across the hall

from the Great Hall, was Ray Penvenen's bedroom and was where he breathed his last. The same room was Thomas Cromwell's office in *Wolf Hall*. All Saints Church, right next to the house, was used for Francis's funeral.

Toads proved somewhat problematic in series three. They were key to the plot but the ones at Great Chalfield couldn't be relied on to play nice or even to show up on the day. Untrained, non-acting toads are just too much of a liability. To ensure that the toads would be in the right place at the right time, the National Trust suggested that the team (humanely) catch some, ready to release on the shoot day. The location manager didn't think waiting around with tiny nets was the ideal plan so they asked permission to bring some toads in from Japan – the country apparently being the go-to place for toads.

The National Trust was concerned, however, that non-local toads might carry disease, so the Trust ecologist came up with a few parameters: each toad should be screened for disease, not enter the water and not mingle with native toads. Cue some very careful toad-watching.

For more on *Poldark*, see the entries for **Botallack**, **Holywell** and **Gunwalloe: Church Cove**.

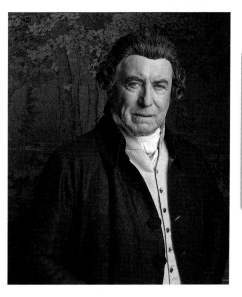

BELOW Construction and lighting teams blacking out and lighting the Great Hall for night shoots.

RIGHT John Nettles as Ray Penvenen.

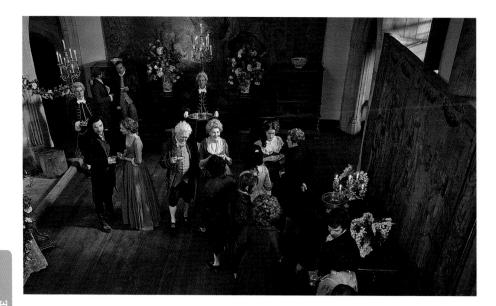

ABOVE Filming *Poldark* in the Great Hall.

RIGHT The arbour from *The Other Boleyn Girl* shoot put to good use in the garden.

The Other Boleyn Girl (2008) 🎥

Directed by Justin Chadwick; starring Natalie Portman, Scarlett Johansson, Eric Bana, Mark Rylance

The house played the Boleyns' country home in this lavish and fast-paced production. Starring Hollywood megastars Natalie Portman and Scarlett Johansson, the story focuses on the sisters' rivalry for the attention of a volatile Henry VIII. The crew spent seven days here filming what would turn into the first 25 minutes of the film.

One of the scenes depicted was Mary Boleyn's wedding celebration which took place at the front of the house. The art department brought in a wicker arbour which the property loved and asked if it could stay after the shoot; the producer agreed and it was added into the garden. Nearly a decade later and now covered in white roses it appeared in an episode of *Poldark*.

Another important scene sees the Boleyn family receiving a royal visit from Henry VIII. A huge feast day was set up, again at the front of the house, with a large entourage and the king all arriving on horseback. Horses and riders arrived in spectacular formation with flags fluttering in the wind, something the house wouldn't have seen for hundreds of years. The

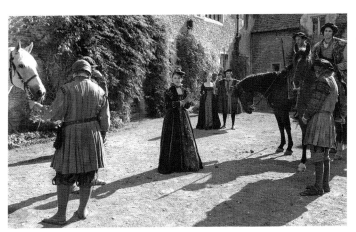

LEFT Anne (Natalie Portman) about to set off for the hunt.

BELOW The King arrives.

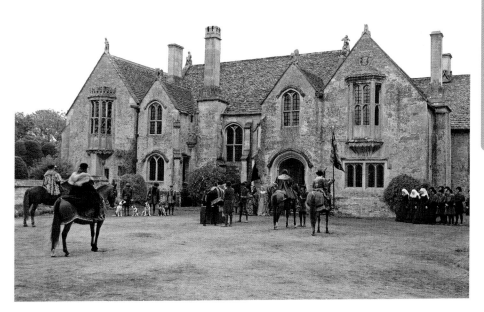

scene when Anne sets off on an ill-fated hunt with Henry was filmed in the area between the stables and the house. All that was required was to remove the cars that are normally parked here and it was good to go.

Around 30 horses were required for these scenes and they all needed somewhere to stay the night. The film crew utilised the stables at the Manor and also brought in horseboxes which they put in one of the adjacent fields.

Income from the film was ploughed back into the upkeep of Great Chalfield. Some was used to re-lay the flagstones in part of the nave of All Saints Church; some to re-roof the stables and some to turn the log-shed into toilets for the public. A big thank you must go to King Henry and his many wives.

The action then moved on to other National Trust properties: **Lacock Abbey** played the interiors of Whitehall Palace and **Knole** the exterior.

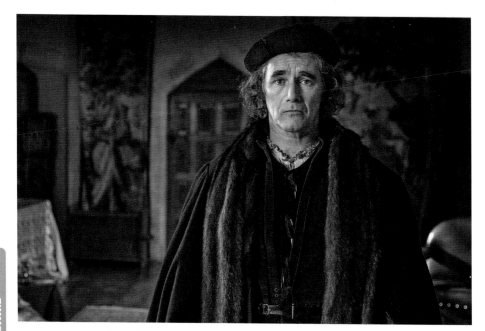

Wolf Hall (2015) 📺

Directed by Peter Kosminsky; starring Mark Rylance, Damian Lewis, Claire Foy, Jonathan Pryce

ABOVE Mark Rylance as Thomas Cromwell.

It was back to the tumultuous Tudor era again when Great Chalfield Manor stood in as Austin Friars in this six-part BBC drama about the life of one of Henry VIII's right-hand men, Thomas Cromwell. Mark Rylance played the lead role, returning to the property after playing Thomas Boleyn in *The Other Boleyn Girl*.

Austin Friars was a complex of buildings occupied by Augustinian friars; Cromwell leased rooms here which he went on to expand into a large residence. It was a huge site, 2.2 hectares (5.5 acres), very near to the location of the present-day Bank of England.

Wolf Hall was notable for its very specific authentic look, achieved by shooting entirely on location and using candles not just in shot but also in 'candle boxes' as a behind-the-camera lighting tool. The crew fixed ten candles into each fireproof box, lined with a reflective backing, the resulting footage making for incredibly immersive TV.

'London' was dropped in for some of the exterior shots; when Thomas Cromwell has a conversation in front of the house instead of seeing the top moat you see the roofs of Tudor houses and the City of London as it would have appeared before the Great Fire of 1666. You also see a well and horse posts, which are not normally there.

This was the first location of a five-month shoot and the crew spent eight days preparing for 12 days of filming, making this the longest single stretch of filming that Great Chalfield has hosted. Much of the building was used: the Great Hall was the setting for family meals, the North Bedroom was Cromwell's bedroom, and the Dining Room his office; it was in this same room that Ray Penvenen from *Poldark* died, poor man.

For more on *Wolf Hall*, see the entries for **Montacute House**, **Chastleton House**, **Barrington Court** and **Lacock Abbey**.

Also filmed at Great Chalfield Manor and Garden: *Robin of Sherwood* (TV, 1984–1986), *Tess of the D'Urbervilles* (TV, 2008), *My Lady Jane* (TV, 2024–)

LACOCK ABBEY

LACOCK, NEAR CHIPPENHAM, WILTSHIRE, SN15 2LG

Lacock Abbey was founded in the early 1200s and was occupied as such for the following 300 years before being sold to courtier Sir William Sharington in 1540 after the Dissolution of the Monasteries. Lacock contains the most complete surviving example of religious cloister complexes in the National Trust's ownership, one of the reasons for the Abbey's popularity with film-makers.

Harry Potter and the Philosopher's Stone (2001), Harry Potter and the Chamber of Secrets (2002) 🎥

Both directed by Chris Columbus; starring Daniel Radcliffe, Emma Watson, Rupert Grint

It is fitting that Lacock should host a large amount of filming as the Abbey was once the home of William Henry Fox Talbot, the pioneer of photography. The oldest photo negative in existence, taken in 1835, is of the window in the Abbey.

These were the films that helped propel Harry Potter into a global cultural phenomenon which shows no sign of abating. It was also the National Trust's first experience of the secrecy surrounding the making of these films; not a word could be leaked and security was tight. Even anglers on the banks of the river were being monitored via telescopes. This was partly to avoid spoilers leaking out, but also because the young cast had to be protected from intense media interest. They were receiving school lessons on set between takes.

Lacock Abbey appeared as parts of Hogwarts, the other locations being a combination of studio settings and six other properties, most famously Alnwick Castle. Lacock's Chapter House provided the Mirror of Erised room, the mirror that reveals Harry's deceased parents.

The Sacristy became Professor Snape's potions class. The Warming Room, which conveniently contains a genuine cauldron, was Professor Quirrell's Defence-against-the-Dark-Arts classroom. Also used were the cloister walks and one of the courtyards.

The first Dumbledore was, of course, Richard Harris who reportedly took the role to please his grandson despite not being in the best of health. Sadly he died in 2002. During filming, one staff member was startled to turn a corner during the shoot to find the actor alone in the cloisters giving himself a vocal pep talk about his performance, the sign of an experienced and dedicated actor throwing himself into the part. Indeed, the Harry Potter films used the cream of the UK's actors, so the filming visitors' book at the Abbey is impressive.

Another concern during the shoot was that the river at the back of the Abbey was flooded and seemed to be advancing towards the set.

Heavy rain is a menace to film locations as the crew rely on scores of trucks, Winnebagos, generators and catering buses. The crews put down trackway, a heavy-duty artificial roadway, but that too can sink into mud in particularly bad weather – a good lesson for when they returned to film *Harry Potter and the Chamber of Secrets*.

Despite the film-makers' best efforts the locations did not remain secret for long and the young tech-savvy Potter fans were soon on the case, spreading the word. Lacock became a focus for fans and soon coach tours began to roll up . . . and they haven't stopped.

Harry Potter and the Philosopher's Stone was also filmed in **Lacock Village**.

BELOW Alan Rickman as Professor Snape, Maggie Smith as Professor McGonagall and Ian Hart as Professor Quirrell in *Harry Potter and the Philosopher's Stone*.

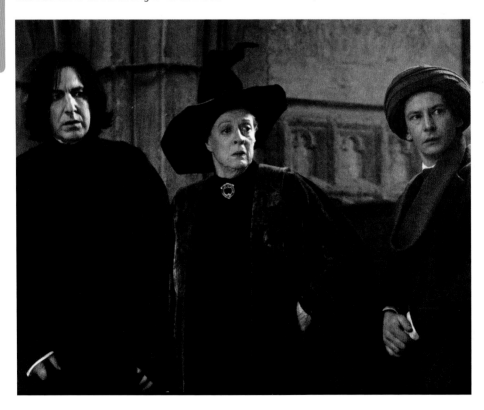

WILTSHIRE

Fantastic Beasts: The Crimes of Grindelwald (2018) 🎥

Directed by David Yates; starring Eddie Redmayne, Jude Law, Johnny Depp

The world of Potter returned to where it all began for this second prequel. In *Fantastic Beasts: The Crimes of Grindelwald*, Albus Dumbledore enlists his former student to track down the dark wizard Gellert Grindelwald, who has escaped custody.

The film takes us back to the days when Dumbledore taught at Hogwarts so it was back into the Sacristy, Chapter House and cloister walks with a new generation of actors gleefully running around the Abbey.

Meanwhile the National Trust team were dealing with their own fantastic beasts, namely bats, of which there are many varieties calling the cloister complex home. Bats are a protected species and it's illegal to cause any disturbance to them, so the crew had to make allowance both in terms of lighting, noise and the owls that formed part of the cast. Thus the National Trust had to track the movements of the bats with the help of a bat ecologist (not to be called Batman) so the crew would know where they would be at certain times of the day. Fortunately bats like a routine. Atmospheric haze, so beloved of film crews, was also kept away from the bats.

It was clear that the crew were happy to be back and a feeling of nostalgia was in the air. Many of them had been with Potter since the first film and for director David Yates this was his fifth Potter film (so far). J.K. Rowling said she was '. . . feeling quite sentimental to be going back to Hogwarts'.

BELOW Albus Dumbledore (Jude Law) in the Sacristy. Gellert Grindelwald (Johnny Depp) was added later using visual effects.

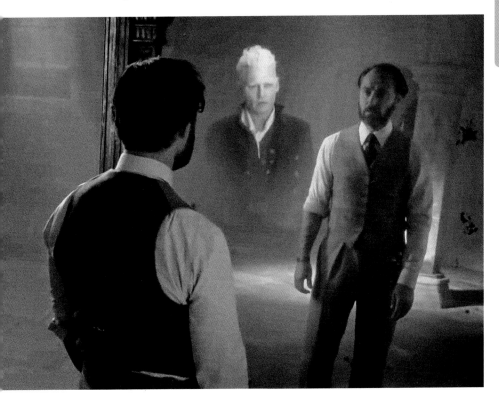

The Other Boleyn Girl (2008) 🎬

Directed by Justin Chadwick; starring Natalie Portman, Scarlett Johansson, Eric Bana, Mark Rylance

Away from wizarding fiction, Lacock is the natural home of costume dramas. In this film, based on Philippa Gregory's novel, Anne Boleyn competes with her sister Mary for the

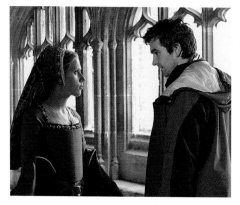

ABOVE Scarlett Johansson (Mary Boleyn) and director Justin Chadwick discuss a scene in the cloisters.

affections of the young King Henry VIII. It won't end well for her.

The Tudor period can be difficult to re-create as few authentic Tudor buildings have survived without radical later changes, especially in the kitchens. Film-makers must jigsaw together their locations from several properties. At Lacock the interior of the Chapter House (minus the Mirror of Erised)

"From a production-design point of view it is five hundred years old, and feels five hundred years old and looks five hundred years old, whereas if you're building sets three or four weeks before you film, however much distressing you do, it's difficult to give it that lived-in feel that feels authentic. It helps bring a realness to the project which is very much at the heart of Hilary's books.

Wolf Hall's producer Mark Pybus on the benefits of filming in a building of the right period.

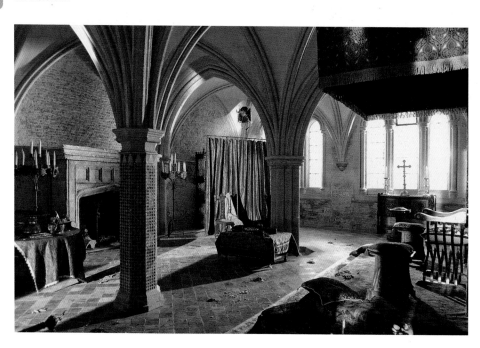

BELOW The Chapter House, where Katherine of Aragon meets the Boleyn sisters.

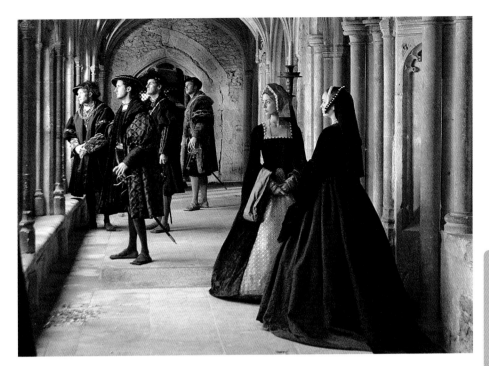

played the Palace of Whitehall where Katherine of Aragon meets the Boleyn sisters. The Palace bathhouse was re-created in the Warming Room. Luckily there is a trough from the original Abbey and an actor was thrown into it once a secure lining had been added and it had been filled with warm water. This scene was dropped in the final edit.

Exteriors of Whitehall were shot at **Knole** and the Boleyn home was **Great Chalfield Manor and Garden**.

Wolf Hall (2015) 📺

Directed by Peter Kosminsky; starring Mark Rylance, Claire Foy, Damian Lewis, Jonathan Pryce

Lacock Abbey's exteriors represented Wolf Hall, the Seymour family seat while the Great Hall interior acted as the King's Chambers in Calais. Amazingly, this was one of the very few times the Great Hall has been used for filming. The Hall was originally commissioned by the

ABOVE *The Other Boleyn Girl* shoot underway in the cloisters.

Talbot family in the Gothic style with a coat of arms decorating the ceiling. Along the walls are a series of sculptures of nuns, philosophers and saints that wouldn't look out of place in a Potter film; indeed, one of them is wearing a wizard's hat.

The National Trust allowed some furniture to be used as the production was running very short of props having already hired so many from the right period for their shoot.

For more on *Wolf Hall*, see **Montacute House, Chastleton House, Barrington Court** and **Great Chalfield Manor and Garden**.

Also filmed at Lacock Abbey: *Pride and Prejudice* (TV, 1995), *The Hollow Crown, Series 1: Henry V* (TV, 2012), *The Hollow Crown, Series 2: Richard III, Henry VI Part 1, Henry VI Part 2* (TV, 2016), *The White Princess* (TV, 2017), *Downton Abbey* (2019), *His Dark Materials* (TV, 2019), *The King* (2019), *The Pursuit of Love* (TV, 2021)

41

LACOCK VILLAGE

NEAR CHIPPENHAM, WILTSHIRE

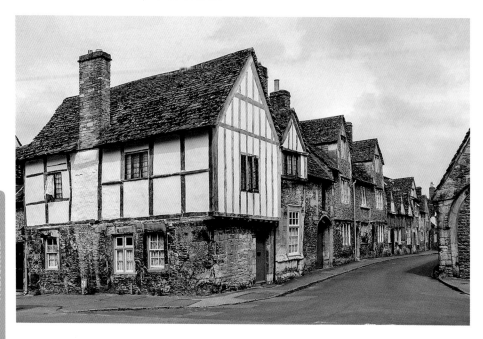

If you've watched any of the most well-loved costume dramas made over the last few decades, or a Harry Potter film, then you've already been to Lacock Village. The village is a firm favourite with film and television drama crews and makes an appearance in a major production at least once every couple of years. Almost entirely owned by the National Trust, the village's pretty streets of timber-framed cottages have barely changed in 300 years. The fact that modern life has barely crept in, outwardly at least, means there's not much in the way of 21st-century life to cover up or remove. Crews don't have to worry about satellite dishes, telegraph poles or traffic lights. As a popular tourist spot filming only happens outside school holidays and other busy times. When it does, it's never small scale.

Cranford (2007 & 2009) 📺
Directed by Simon Curtis, Steve Hudson; starring Judi Dench, Eileen Atkins, Imelda Staunton, Philip Glenister

In early summer 2007, Lacock was packed full of the country's finest female acting talent, all wearing some rather wonderful bonnets. The village had been chosen to star as Cranford itself in the five-part adaptation of three of Elizabeth Gaskell's novels. A huge success when it transmitted in 2007, a Christmas special followed two years later. Unusually for the time, Gaskell's stories are female-focused and it's the single and widowed ladies of the town who rule this particular roost.

The cast list was more than stellar: Judi Dench took the title role as Miss Matty Jenkyns and was joined by Deborah Findlay, Imelda Staunton, Julia McKenzie, Eileen Atkins, Barbara Flynn, Lesley Manville and Francesca Annis. There were also some men in it.

Times are changing and there's concern

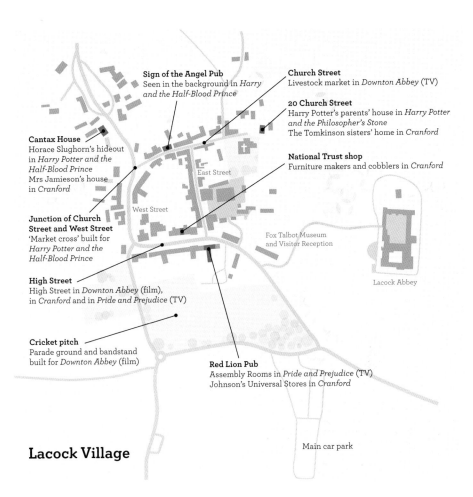

Sign of the Angel Pub
Seen in the background in *Harry and the Half-Blood Prince*

Church Street
Livestock market in *Downton Abbey* (TV)

20 Church Street
Harry Potter's parents' house in *Harry Potter and the Philosopher's Stone*
The Tomkinson sisters' home in *Cranford*

Cantax House
Horace Slughorn's hideout in *Harry Potter and the Half-Blood Prince*
Mrs Jamieson's house in *Cranford*

National Trust shop
Furniture makers and cobblers in *Cranford*

East Street

Junction of Church Street and West Street
'Market cross' built for *Harry Potter and the Half-Blood Prince*

West Street

Fox Talbot Museum and Visitor Reception

High Street
High Street in *Downton Abbey* (film), in *Cranford* and in *Pride and Prejudice* (TV)

Lacock Abbey

Cricket pitch
Parade ground and bandstand built for *Downton Abbey* (film)

Red Lion Pub
Assembly Rooms in *Pride and Prejudice* (TV)
Johnson's Universal Stores in *Cranford*

Main car park

Lacock Village

over how the railways will impact rural life, if Charles Dickens is acceptable reading material, and how one should eat something as 'incommodious' as an orange politely. Plus, there's a new young doctor in town – unmarried.

Lacock Village needed to be returned to 1840 and would appear in every episode so this made it one of the most complex and lengthy shoots that's ever taken place here. The crew were on-site for nearly a month – a week preparing the set, two weeks of filming day and night scenes and then another week to put everything back to normal.

The week before the shoot, the art department moved in. There was a lot to be done; nearly all key players live in the village

itself, so all needed a house and much of the rest of it would be seen at some point. A total of 34 houses had some sort of tinkering carried out: downpipes and front doors were painted, planting was removed, net curtains replaced, signs covered and modern items taken off the window ledges.

Some houses were transformed into village hot-spots: the National Trust shop became two shops, a furniture maker's on one side with a cobbler's on the other; the Red Lion pub was turned into the village shop and the hub of local activity and gossip, 'Johnson's Universal Stores'. A fake front was added onto the building so that real customers and staff could still access the pub from the side, invisible to the viewer of course. The village's bakery

RIGHT The start of the dirt road.

BELOW The National Trust shop transformed into a furniture makers and a cobblers.

BOTTOM The market scene.

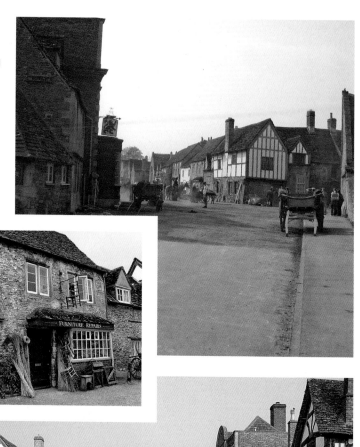

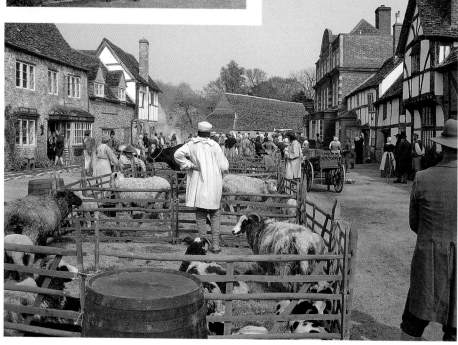

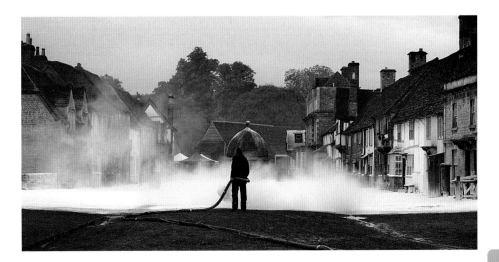

ABOVE The snow being laid.

played itself, sort of, becoming Cranford's bakery.

All house interiors were filmed in a studio as the real ones are too small to accommodate actors, crew and all of their equipment. A fibreglass jail was built in the middle of the High Street and a mixture of sand, gravel and soil was put down on all ground that would be in shot. The house used as the Tomkinson sisters' home, with its large front garden, is also Harry Potter's childhood home in *Harry Potter and the Philosopher's Stone*. Cantax House on Cantax Hill was the exterior of Mrs Jamieson's house and is also seen in *Harry Potter and the Half-Blood Prince*. The garden in front of Miss Pole's house was completely new and built on.

Carts, market stalls and produce were all brought in for the market scene on the High Street. Joining them were ducks, cows and sheep, all of which are trained and come with their own handlers.

The tithe barn (which you can visit) was used as a props store and the National Trust holiday cottage (which you can stay in) as a green room for cast. Some of the stars could be spotted when they used the High Street to form a knitting circle in-between takes.

The location manager and the National Trust's general manager decided that, to

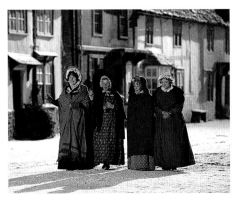

ABOVE Cranford's ladies on the move – Judi Dench second from right.

reduce disruption for residents, scenes on one road would be completed before filming on another road could start. For some scenes the location manager had to divert a bus route and cars had to be stopped driving into shot. The cast were all back in summer 2009 to film a Christmas special and this time the village was covered with snow, a bit of a surprise for the tourists there that day.

Other National Trust sites were also used; the garden house at **Osterley Park and House** played the one in the grounds of Lady Ludlow's estate and part of the **Ashridge Estate** was used as Cranford Green, where the carriages meet before a garden party.

Pride and Prejudice (1995) 📺
Directed by Simon Langton; starring Jennifer Ehle, Colin Firth, Benjamin Whitrow, Alison Steadman

Lacock proved the perfect setting for Meryton in the iconic BBC adaptation of Jane Austen's well-loved novel. Meryton is where the Bennet sisters go for gossip, bonnet shopping and ideally an encounter with certain members of the local militia. It's also the scene of Lizzie's first not-so-pleasant encounter with Mr Darcy, at a ball at the Assembly Rooms.

Like *Cranford* much of the village would be seen, so dirt was put down onto the ground and the early nineteenth century was ushered back in. This time the National Trust shop was turned into a grocer's and the Red Lion pub became the exterior of the Meryton Assembly Rooms. The interior was built in a studio as there wasn't a large enough room inside for the dancing. Horses, carriages, dogs and water troughs all arrived on site ready for the day and night shoots.

The crew also popped down to **Lacock Abbey** to film some scenes in the cloisters, which played a Cambridge college in a flashback to Mr Darcy's student days. For the very famous Mr Darcy moment you'll need to visit the **Lyme** page. He was also spotted at **Belton House**.

There was huge interest in the production and on one day alone the BBC came to film a behind-the-scenes piece for a current affairs show, a group of local school children were on set to learn about film-making, and at one point 300 or more spectators arrived to see the action. Everyone clearly had a strong inkling this was going to become compulsive viewing.

BELOW Mr Darcy (Colin Firth) arrives in the village.

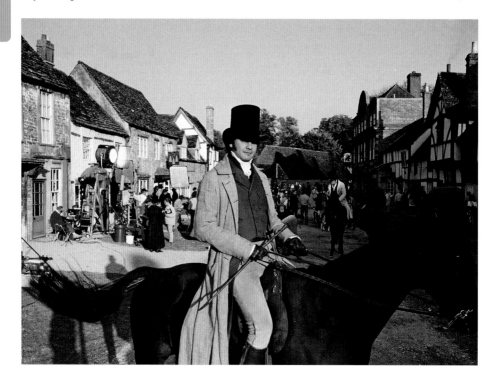

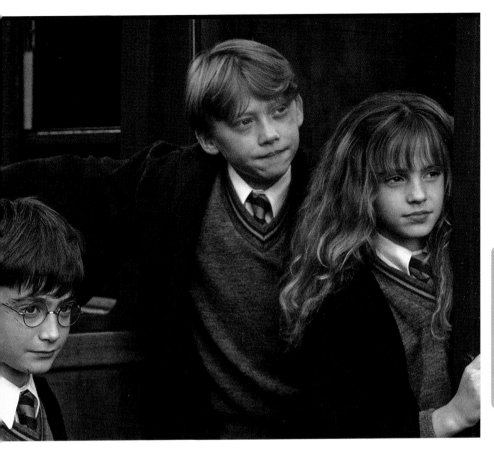

Harry Potter and the Philosopher's Stone (2001) 🎥◄

Directed by Chris Columbus; starring Daniel Radcliffe, Emma Watson, Rupert Grint

ABOVE Harry (Daniel Radcliffe), Ron (Rupert Grint), Hermione (Emma Watson) and the Hogwarts Express.

A house tucked away in a corner of the village, number 20 Church Street, was chosen as Harry Potter's childhood home in 'Godric's Hollow'. The same house would be used later as the Tomkinson sisters' home in *Cranford*. The house can be found to the left of St Cyriac's Church. Voldemort is seen coming through the garden gate up to the front door and into the house.

Wanting an atmospheric moonlit sky the lighting team asked if they could put a huge crane into the National Trust's estate office yard and hang an equally huge light from it to create the desired effect. When the time came to film the scenes the pesky real moon decided to appear in shot and they had to wait until it had moved before they could turn their 'moonlight' on. School children from the village got a treat when the location manager took them to see the set – a bonus to growing up in Lacock.

Scenes for the film were also shot at **Lacock Abbey**.

Harry Potter and the Half-Blood Prince (2009) 🎥

Directed by David Yates; starring Daniel Radcliffe, Emma Watson, Rupert Grint

TOP Filming at the 'market cross'.

ABOVE Harry and Dumbledore (Michael Gambon) arrive at the gates of Cantax House.

In this film Lacock makes an appearance as Budleigh Babberton village, where Dumbledore and Harry go to find Professor Horace Slughorn. They leave Surbiton station and transport themselves to the village, not via South Western Railway. Horace is hiding in Cantax House, a perfectly proportioned Georgian house set back from the road on Cantax Hill. It also played Mrs Jamieson's house in *Cranford*.

The filming was only at night, 7pm to 5am, over two nights. This had its advantages as they could cone off the required roads without too much disruption to the village, though it

did mean they had to put blackout blinds in the windows of all nearby houses. Nothing in Potter world is done by halves and the art department worked in three separate teams over 11 days painting houses and adding false fronts and extra thatch. The market cross that Dumbledore and Harry stand next to just before they leave the village isn't normally there and was built by the crew at the junction of Church Street and West Street. The Sign of the Angel pub can also be spotted as Dumbledore and Harry walk past it.

Harry Potter and the Half-Blood Prince was also filmed at the **Ashridge Estate**.

Downton Abbey (2010–2015) 📺
Directed by various; starring Hugh Bonneville, Elizabeth McGovern, Michelle Dockery, Jim Carter

ABOVE The Crawley family enjoying the livestock market.

Lacock made an appearance in series six, episode two of *Downton Abbey* when Church Street was transformed into a bustling livestock market. Activity spanned three days in February 2015 and all the main cast were on site as well as pigs, sheep, cows and a one-tonne long-horned bull. Animal pens were brought in and filled with hay and 90 supporting artists milled around; one of them was a visitor welcome volunteer at Lacock Abbey, who said, 'The amount of detail going into the production was astonishing. I was cast as a farmer and they even went as far as applying dirt to the back of my hands as I had supposedly been working in the fields.' What would Mr Carson say?

For more on the *Downton Abbey* TV series, see the entry for **Basildon Park**.

Downton Abbey (2019) 🎬

Directed by Michael Engler; starring Hugh Bonneville, Elizabeth McGovern, Michelle Dockery, Jim Carter

The movie version of the hugely successful, award-winning TV series had been mooted ever since the series ended in 2015. Speculation was rife about the plot, the release date and which characters would be returning. Press interest was therefore enormous and the paparazzi took full advantage of this very public filming.

It is not every day that the Royal Artillery gallops through a village complete with cannons. The real RA was hired by the film-makers to add accuracy and authenticity to scenes of a visit from the king. The plot was a closely guarded secret but they could not hide the filming itself as Church Street was turned into a livestock market before making way for the military parade. The village was dressed for the 1920s with bunting to welcome the royals. Many residents became flag-waving supporting artists. The street was a riot of colour with the sun gleaming off the uniforms and the brass of the cannons. The horses were led, often with one person controlling three horses, through the village and back via a side road to re-appear in Church Street for the next take.

Also filmed at Lacock Village: *The Moonraker* (1958), *Emma* (TV, 1996), *The Fortunes and Misfortunes of Moll Flanders* (TV, 1996), *Randall and Hopkirk (Deceased)* (TV, 2000–2001), *The Mayor of Casterbridge* (TV, 2003), *Agatha Raisin* (TV, 2014–), *Doctor Thorne* (TV, 2016), *The White Princess* (TV, 2017)

BELOW Laura Carmichael (Lady Edith), Harry Hadden-Paton (Bertie Pelham) and Michelle Dockery (Lady Mary) between takes.

STOURHEAD

NEAR MERE, WILTSHIRE, BA12 6QF

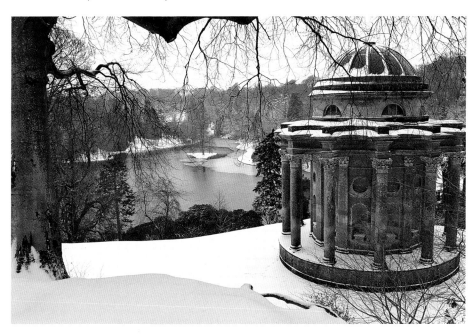

The world-famous landscape garden at Stourhead has been delighting visitors for over 250 years. At its centre is a magnificent lake surrounded by classical temples, mystical grottoes and rare and exotic trees. A contemporary magazine described the garden as a 'living work of art'.

Pride and Prejudice (2005) 🎥

Directed by Joe Wright; starring Keira Knightley, Matthew Macfadyen, Brenda Blethyn, Donald Sutherland

A rain-soaked Darcy makes his first, unsuccessful proposal to a rain-soaked Lizzie at Stourhead's Temple of Apollo. Set high above the lake, the dramatic setting and beauty of the Temple proved perfect for this intense and romantic scene. So perfect in fact that the film's director Joe Wright didn't need

Adam Richards, the film's location manager, to go and look for a setting for this scene as Joe had always imagined it taking place here. Adam explained why the Temple was the director's first and only choice: 'Joe loved the idea of this emotional scene being played out while sheltering from the elements. The Temple, with its elevated position over the gardens below, was the ideal backdrop.'

Upset by what she's just learnt about Darcy's character and hoping for some solitude, Lizzie runs here from a church (not National Trust) via the Palladian Bridge, also at Stourhead. The five-arched Bridge can be spotted briefly, silhouetted in the late summer light.

The art department spent two days on site readying the set. A flat, cobbled-looking surface was placed over the Bridge's grass floor as running in the rain in a long dress would have been tricky at best and unsafe at worse. They scraped bits of algae off the Temple to make it look more recently built and

❝I love you, most ardently. ❞

Darcy declares his feelings for Lizzie.

placed a cordon around it with signs asking that people stay off the surrounding grass for a few days in case their footprints could be spotted on camera.

Filming in a vast landscape like this can have its logistical challenges as the car park is never in the right place for all the equipment trucks. In this case there was also the wind and rain machines to take into consideration; both needed to be close to hand to ensure a suitable level of drenching. The crew got round this by setting up a mini car park on the flattest possible ground nearby.

The upside to the vastness is that despite the shoot taking place in August, the busiest time of year, the garden could remain open to visitors while the hundred-strong crew worked away in one corner. As is normal practice in open spaces, the location manager dotted some of his team around to ask people to hold while the cameras were rolling. This works well as it's only ever for a few minutes at a time. The Bridge shot, needing a wider angle, was filmed in the early morning before visitors arrived.

Keira Knightley's first National Trust location shoot was at Stourhead; she's since become a regular after going on to shoot other scenes for the same film at **Basildon Park**, as well as scenes for *The Duchess* at **Kedleston Hall, Osterley Park and House** and **Basildon Park**, and *Never Let Me Go* and *Anna Karenina* at **Ham House and Garden**.

For more on this film, see the entry for **Basildon Park**.

Also filmed at Stourhead: *The Pursuit of Love* (TV, 2021)

BELOW Keira Knightley as Lizzie Bennet at the Temple of Apollo.

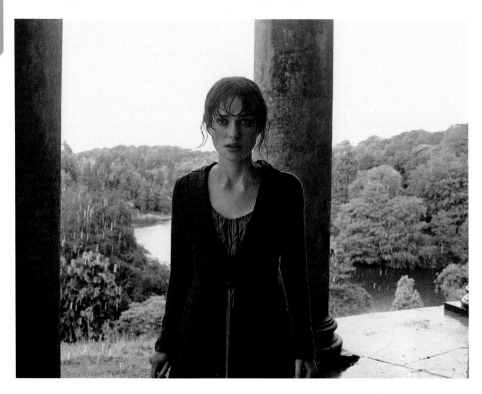

DYRHAM PARK

DYRHAM, NEAR BATH, SOUTH GLOUCESTERSHIRE, SN14 8HY

Dyrham Park is a magnificent seventeenth-century Baroque mansion house notable for its collection of Dutch paintings and porcelain. The 110 hectares (270 acres) of parkland are home to a historic herd of fallow deer.

Dyrham was used as the interiors of the doll's house, the checked floors and staircase helping to create the illusion. Trust furniture was removed and simpler, more worn or 'played with' prop furniture substituted. The house is heavily Dutch influenced, which was useful as peg dolls originated in the Netherlands.

The episode was written by Mark Gatiss who has had a fear of wooden dolls since childhood. Presumably a whole new generation also now has the same fear. One of the Doctor's assistants, Clara Oswald, has hinted that she has met Jane Austen; should Gatiss write an episode based on that meeting the National Trust isn't short on suitable locations.

Not all *Doctor Who* viewers will be children as this episode was watched by seven million people in the UK alone and even the most popular children's show can expect about 500,000. *Doctor Who* has been building an audience since 1963.

Doctor Who (Series 6, 2011) 📺
Directed by Richard Clark; starring Matt Smith, Karen Gillan, Daniel Mays

In the episode 'Night Terrors', the Doctor, played by Matt Smith, pops in on a scared eight-year-old boy who is frightened of his bedroom cupboard. His fear is travelling the universe. While the Doctor is discussing the case with the boy's dad, his companions Amy and Rory get caught in a doll's house occupied by life-size peg dolls.

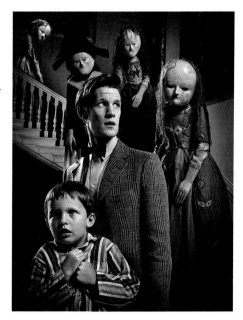

RIGHT Matt Smith, as Doctor Who, on the white staircase at Dyrham Park.

The Remains of the Day (1993) 🎥

Directed by James Ivory; starring Anthony Hopkins, Emma Thompson, Peter Vaughan

Some films create their locations from several real ones, this is known as the jigsaw effect. In *The Remains of the Day*, 'Dartington Hall' was the home of pro-Nazi Lord Dartington whose faithful servant Stevens has suppressed feelings for his housekeeper Miss Kenton. Stevens also questions his opinion of Lord Dartington. The film, based on the award-winning novel by Kazuo Ishiguro, was nominated for eight Oscars.

Dyrham was used as the exteriors of Dartington, including the hunting scene. The interiors were provided by three other stately homes, none of them belonging to the National Trust: Badminton House, Powderham Castle and Corsham Court.

The filming marked a turning point for the National Trust. Although the film was a prestige production by Merchant Ivory, kings of successful, art-house, costume dramas, their first request to use Dyrham as the film's location was declined. This was long before the Trust's Filming and Locations Office was set up and the main concern was conservation and operational issues. Anthony Hopkins spoke up about the opportunity the Trust was missing. The Trust changed their mind and the later success of *Pride and Prejudice* at **Lyme** – which more than doubled visitor numbers – cemented the decision to change direction. Sir Anthony clearly forgave us as in 1998 he kindly and generously donated £1 million towards the National Trust's Snowdonia appeal.

ABOVE Anthony Hopkins as Stevens and Emma Thompson as Miss Kenton.

RIGHT The hunt scene.

The Pursuit of Love (2021) 📺
Directed by Emily Mortimer; starring Lily James, Emily Beecham, Andrew Scott

ABOVE Lord Merlin (Andrew Scott) and his silk pyjamas in the Gilt Leather Parlour.

When the March 2020 lockdown came into force, the BBC were just two weeks away from starting to film an adaptation of Nancy Mitford's novel *The Pursuit of Love*. The government soon made the film and TV industry a special case, meaning shoots could continue but with strict rules. The crew sprang into action and managed to get going again in the summer.

Mitford's semi-autobiographical tale satirises her family history and follows Linda Radlett and Fanny Logan, two cousins and best friends, as they search for love and happiness, whilst wearing some rather fabulous 1930s and 40s costumes.

Covid meant that the traditional technical recce, where all the heads of departments and their teams visit a location, simply couldn't happen. Each department had to remain in their 'bubble' and visit separately, and the dining bus was abandoned. Testing was carried out daily and the new role of Covid Coordinator was created to ensure the crew's adherence to the rules.

One advantage was that National Trust houses were closed, and the production needed to film as much as possible in the chosen locations to minimise travel. Dyrham doubles as parts of Alconleigh, the Radlett family home. The Gilt Leather Parlour was dressed as a ballroom for two coming out balls and was also where Andrew Scott danced in silk pyjamas – a treat for the property staff! The Great Hall made an appearance when Linda had her first London dance and the Plod Room starred as a London bookshop.

The exterior of **Lacock Abbey** stands in for Christ Church College, Oxford; Linda and Fanny go to a party there and some undergraduates jump in the river for a skinny dip. **Stourhead** joined the fun by hosting a nightclub scene, as well as standing in as Linda's elegant Parisian apartment.

Also filmed at Dyrham Park: *Sense and Sensibility* (TV, 2008), *Poldark* (TV, 2015–2019), *Sanditon* (TV, 2019)

WOODCHESTER PARK

NYMPSFIELD, NEAR STROUD, GLOUCESTERSHIRE, GL10 3TS

This quiet, wooded valley holds many secrets, as among 212 hectares (524 acres) of countryside and lakes lies the remains of a landscaped park built in the eighteenth and nineteenth centuries, much of it still being discovered. The pretty boathouse is home to the rare lesser horseshoe bat.

The Crown (2016–) 📺
Directed by various; starring Claire Foy, Matt Smith, Greg Wise

The Crown was a huge hit the moment the first series premiered on Netflix in December 2016, a highly anticipated second series followed a year later. The show was a landmark for Netflix marking their arrival as a serious player in broadcasting as well as ushering in a new era

of cinematic high quality drama that can be watched at the viewer's own pace. Or, let's be honest, in one or two glorious sittings.

Based on Peter Morgan's play *The Audience* and beginning in the late 1940s, the lavishly-made drama examines the life of Queen Elizabeth II and the relationship with her prime ministers. By series two Elizabeth's two eldest children are growing up and a school needs to be found for Charles. Elizabeth is keen on Eton but Philip prevails, he wants Charles to attend far-flung Gordonstoun in northern Scotland, his own alma mater. In the script the Queen says Charles calls the school 'Colditz with kilts'.

The Gordonstoun scenes in series two, episode nine, 'Paterfamilias', were actually filmed in Gloucestershire. Woodchester Mansion, not owned by the National Trust, provided both the exterior and interior of the school and the National Trust-owned estate

> *"We have been able to improve our visitor car park, with all of our car park spaces now on hard ground. It will also help us to restore grasslands to increase feeding grounds for the greater and lesser horseshoe bats that roost in the valley."*

Woodchester Park's area ranger explains how welcome the location fee was.

was used to film six days of outdoor scenes. The episode covers both Philip's time there in the 1930s, seen in flashback, and Charles's in the 1960s.

Boys are seen running through the muddy fields surrounding the house, as well as taking part in an assault course. Important scenes in Philip's time there centre around the nineteenth-century boathouse – including a scene where he is thrown out of the window into the lake. A window seat was built inside, period looking scaffolding was added around it and a pontoon onto the water.

Due to the presence of bats, a Trust ecologist was brought in to advise the crew what time of day they could film, oversee lighting positions and ensure that the set didn't block bat entry and exit routes. Even royalty must make way for bats.

The Crown filmed at **Stowe** for their third series.

BELOW Finn Elliot on site at Woodchester playing the young Prince Philip.

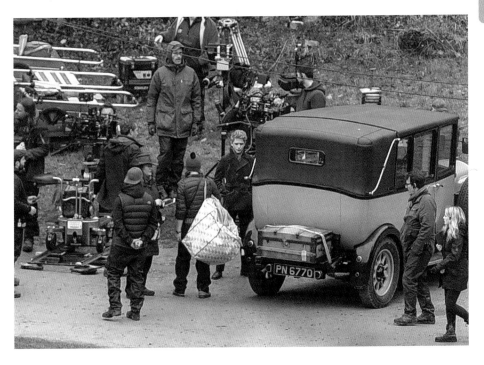

CHASTLETON HOUSE

CHASTLETON, NEAR MORETON-IN-MARSH, OXFORDSHIRE, GL56 0SU

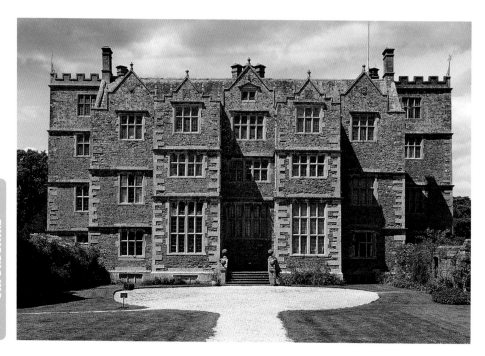

Atmospheric Chastleton House in rural Oxfordshire has remained largely unchanged for four hundred years. The lack of modernisation was due to the family's dearth of funds, one of them explaining in the 1930s that her ancestors had run out of money 'during the war' – she was referring to the English Civil War. This intriguing time capsule is a rare gift for film-makers, albeit a very fragile one.

Wolf Hall (2015) 📺
Directed by Peter Kosminsky; starring Mark Rylance, Damian Lewis, Claire Foy, Jonathan Pryce

Unlike **Montacute House** which represented one place in *Wolf Hall*, parts of Chastleton stood in as a wide variety of different locations in the story.

The stableyard was set up as a blacksmith's yard in Putney for scenes involving Cromwell and his blacksmith father. What was at the time the visitor reception and the space in front of it were transformed into a blacksmith's forge, complete with a horse. Straw went down on top of polythene sheeting. It was there to protect the ground from any horse expulsions which have the potential to stain. The set builders covered the ticket office with 'flattage', bits of fake wall, actually made of wood, used by crews for all kinds of set-building purposes. Animal pens, straw fences, faux cobbles and a well completed the transformation.

Clever lighting and camera angles turned the basement beer cellar and the house's internal courtyard, known as Dairy Court, into a London tavern. Some ladies of ill-repute cheekily flashed their top halves from a window high up in the courtyard, actually a

staff member's bathroom. That's got to be a National Trust first.

The house also played York Place in London when the Long Gallery appeared in the first scene of episode one; for more on that see the **Montacute House** entry. Another memorable scene was filmed here, when Anne Boleyn and Thomas Cromwell look out of the same window to witness the resignation of Thomas More.

Only five rooms in the house weren't used. Chastleton's interiors were used for Cromwell's bedroom, the Great Hall at Wolf Hall and for Cawood Castle, a palace belonging to the Archbishops of York. The same rule applied here as it did for all other properties appearing in the series: no lawn

mowing was allowed in the two weeks leading up to the shoot. Stripes are clearly a modern obsession.

For more on *Wolf Hall*, see the entries for **Montacute House**, **Lacock Abbey**, **Barrington Court** and **Great Chalfield Manor and Garden**.

Also filmed at Chastleton House: *Father Brown* (2013–)

RIGHT The Long Gallery.

BELOW The stableyard as it normally is; what was then the visitor reception, used as the blacksmith's forge, is the building on the right.

BASILDON PARK

LOWER BASILDON, READING, BERKSHIRE, RG8 9NR

BERKSHIRE

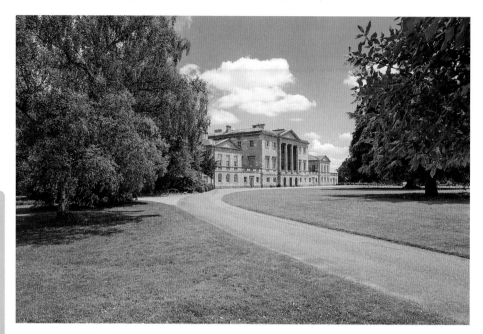

This eighteenth-century house and its 162 hectares (400 acres) of parkland was facing demolition until lovingly restored in the 1950s by Lord and Lady Iliffe. The house's elegant classical interiors, designed by architect John Carr and heavily influenced by Robert Adam, appeal to film-makers, especially those needing a spacious room for a ball.

Pride and Prejudice (2005) 🎥

Directed by Joe Wright; starring Keira Knightley, Matthew Macfadyen, Brenda Blethyn, Donald Sutherland

It is a truth universally acknowledged that this shoot was, at the time, the most ambitious ever undertaken by the National Trust and still remains one of the biggest projects achieved. Director Joe Wright was not just attracted to the house because it fitted the period and is

rather lovely; he was drawn by the fact that it has a series of interlocking rooms without corridors. His ambition was to follow several characters as they arrive and mingle with fellow guests during the Netherfield ball – all in one shot. Basildon was therefore perfect for the camera to roam using a steadicam (a camera harness attached to the cameraman that allows smooth movement). It would be a method Joe Wright would use again in *Atonement,* in which an even longer single take captures the carnage of Dunkirk. It is known in the trade as 'the Goodfellas shot' after Martin Scorsese's famous nightclub scene in the film of the same name.

But before the house could become Netherfield, home of Mr Bingley and where Elizabeth Bennet could cross paths with Mr Darcy, a lot of work was required. BAFTA-winning production designer Sarah Greenwood wanted to redesign the Octagon Room and tweak the look of other spaces. Netherfield's luxury was to contrast with the

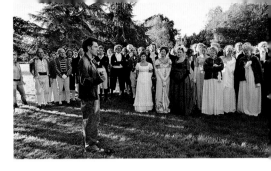

homely surroundings of the Bennets' house. The words 'cold' and 'stark' were cited as the best way to realise Netherfield, although, for its day, Basildon would have been deemed a comfortable, modern house. In a film, atmosphere and mood have to be conveyed instantly as first impressions are all you get. Often a location can be exactly in the right period for the script but be rejected because it doesn't contrast enough with another location or projects the wrong ambience. If your characters are having an intimate conversation then you would not set it in a grand cavernous ballroom with an expansive view from the window as it would distract the viewer from the dialogue.

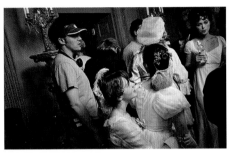

The National Trust needed to protect any fragile furniture that couldn't be moved. Ornate mirror frames were protected in situ and then hidden behind prop walls or 'flattage'. A room within a room was built to disguise the red felt-covered walls of the Octagon Room. Lighting scaffolding was hidden in false columns. A bar of scaffolding goes across from the two columns hence the shorthand term 'goal-post'. Just removing one carpet took over twenty people and a scissor lift.

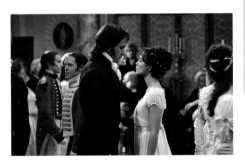

Elaborate formal dances were performed (like a Georgian dating app) again and again with the main cast moving with balletic precision. Dancing was crucial to the social scene in the late eighteenth century. The whole family would attend and strict etiquette would apply to this courting ritual. Often dancing was the only way to talk to – or in this case exchange pithy dialogue with – someone you may be keen on.

Balls were also the important event of the calendar as reflected in the number of supporting artists involved; two hundred were on site, 10 of whom were National Trust staff keeping an eye on things. Actors had all been given etiquette and movement classes and the dances themselves were rehearsed repeatedly

FROM TOP TO BOTTOM Director Joe Wright delivers instructions to the supporting artists; Joe Wright and the cast between takes, Keira Knightley far right; Lizzie (Keira Knightley) and Darcy (Matthew Macfadyen) at the ball; The cast enjoying the view of the parkland.

off-site before filming. The dancing and quieter scenes took ten days to shoot in total.

This film is probably second only in fame to the 1995 BBC version but it is a story that has been returned to many times and in many forms, including a stage musical. The Bennets have even fought zombies. The book and author's popularity have never waned; Jane Austen's influence is all-pervasive – *Bridget Jones's Diary* being a typical example. In 2008 TV's *Lost in Austen* series saw a modern-day, Austen-worshipping heroine swap places with Elizabeth Bennet via a time warp. Some of the series was shot at East Riddlesden Hall and Nostell.

P.D. James wrote *Death Comes to Pemberley*, taking the marriage forward six years and throwing in a murder. Television took this up in 2013 with some of the shoot using Hardcastle Crags and **Fountains Abbey and Studley Royal Water Garden**.

For more on *Pride and Prejudice*, the film, see the entry for **Stourhead**.

BELOW The Trust team roll up the Octagon Room carpet. The crew could then begin work constructing a new-look room within the room.

ABOVE The carpet being removed from the house using a scissor lift.

RIGHT A piece of 'flattage' coming into the house. It would form part of the new look Octagon Room.

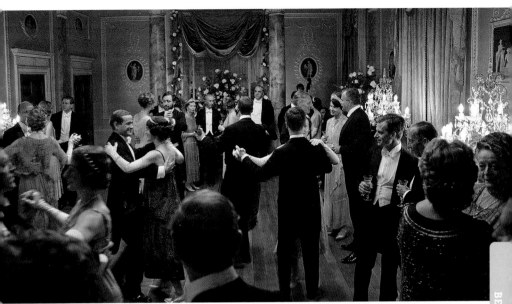

Downton Abbey (2010–2015) 📺
Directed by various; starring Elizabeth McGovern, Hugh Bonneville, Michelle Dockery, Shirley MacLaine, Lily James

ABOVE The coming out ball in full swing.

Downton Abbey immediately became compulsive Sunday-night viewing when it first hit the small screen in 2010. It remained so throughout its six-series run during which an unprecedented number of fans regularly tuned in for their fix of the aristocratic Crawley family and their servants. A National Trust house wasn't chosen to play Downton Abbey itself, the honour instead going to the privately owned Highclere Castle in Hampshire.

Ham House and Garden and Greys Court appeared briefly in series two and three but it wasn't until series four that a National Trust property had its big moment in the show. Much of the feature-length 2013 Christmas special 'The London Season' was shot at Basildon Park when it became the Crawley family's London home, Grantham House. The episode's action centred around Lady Rose MacClare's 'coming out' for the 1923 London season and the hectic social whirl that would accompany it. Ten days of filming was carried out in the hot summer of 2013.

In the story the house was supposed to be located in St James's Square in London so the exterior was filmed at Bridgewater House in Westminster (not National Trust). Bridgewater House is very large and grand so the location manager needed some impressive interiors to match it; Basildon Park was deemed ideal. Nearly all the reception rooms are seen in the episode including the Entrance Hall, Staircase Hall, Dining Room, Library and Octagon Room. The 'below stairs' scenes were filmed at Ealing Studios as were those set in Downton Abbey. Basildon's basement doesn't have an historic kitchen as it was converted into the visitors' café many years ago.

All the main cast were on location at Basildon, including, rather excitingly, Hollywood legend Shirley MacLaine, reprising her role as Cora's mother, Martha Levinson. Paul Giamatti was a newcomer, joining the cast to play Cora's rakish playboy brother, Harold Levinson. Martha and the Dowager Countess of Grantham (Maggie Smith) never

63

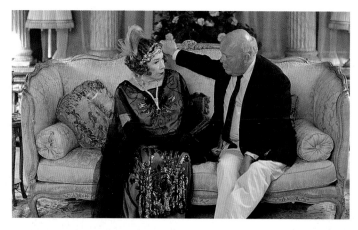

LEFT AND BELOW Shirley MacLaine and the show's creator, writer and executive producer Julian Fellowes in conversation in the Octagon Room.

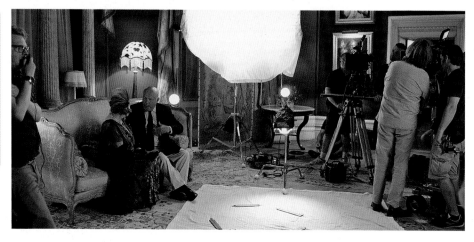

really got along – a treat for the viewer as there is really nothing like seeing a Dame and a Hollywood legend sparring in tiaras.

Rose's debutante ball was a glittering evening with the men dressed in white tie and the ladies in diamonds galore. The Dining Room was the elegant backdrop for Rose's big night, which included a dance with the Prince of Wales, the future King Edward VIII. The room is Basildon's largest and was also the setting for that other important ball at which Elizabeth and Mr Darcy dance. There were no candles to keep an eye on this time, as *Downton Abbey* is set in the era of electricity.

The Trust team removed the room's dining table, carpet, small tables and lamps and stored them, as they did for *Pride and Prejudice*, in a room in the basement. However, this time the walls of the Octagon Room were seen in all their dark red glory. A gentleman's card game in the Library required cigars; herbal ones are used which leave no lingering smell and are far easier on the actors. The production returned a year later for one week's filming for series five when again Basildon Park stood in for the interiors of Grantham House.

For more on *Downton Abbey*, both TV series and film, see the entry for **Lacock Village**.

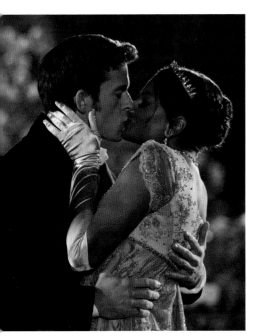

Bridgerton (2020–) 📺
Directed by various; starring Jonathan Bailey, Simone Ashley, Polly Walker, Nicola Coughlan

The highly anticipated second series of the Netflix smash hit *Bridgerton* arrived on screens in 2022, this time charting eldest son Anthony's adventures in the Regency marriage market. Soon, sales of croquet sets were rocketing, undoubtedly due to Anthony and his love interest Kate's highly charged scenes playing pall-mall (an early form of croquet). The Bridgerton effect was in full swing. The two brought their crackling chemistry to Basildon Park when the property appeared in the series finale's Featherington ball scenes.

Filming was centred in and around the garden so there were lots of lingering views of the back of the house. Not having been seen on camera before, you'd never know it was the same property that portrayed 'Netherfield' in *Pride and Prejudice*. Never ones to do anything by halves, the *Bridgerton* 'greens' department brought 5,000 artificial flowers with them which were then intertwined with fake foliage to create a dazzling backdrop for the action.

As action moved outside, Portia and Lord Featherington had a conversation in the Garden Room, another part of the property enjoying its first outing on screen. At the very end of the episode the full effect of the roses can be seen when Kate and Anthony talk and everyone gathers to watch fireworks with 'London' in the distance. They, and London, were added in later using visual effects. Another separate scene involving a top-off moment was also filmed in the garden.

Bats are in residence at Basildon and night shoots could disturb them, so it was stipulated by the National Trust that filming lights had to be turned off at twilight for an hour, and then again at dawn for an hour and 40 mins. There was a complete ban on lighting to one side of the house as it is home to maternity roosts. The shooting schedule was then planned around these rules. If you look close enough, you may see one or two fly into shot as supporting artists!

For more *Bridgerton* see **Stowe** and **Petworth**.

Also filmed at Basildon Park: *The Duchess* (2008), *Dorian Gray* (2009), *Pride and Prejudice and Zombies* (2016), *The Crown* (TV, 2016–), *Belgravia* (TV, 2020–)

TOP Anthony (Jonathan Bailey) and Kate (Simone Ashley) romancing in Basildon's garden.

ABOVE Anthony shocked that he has lost his shirt, also in Basildon's garden.

CLIVEDEN

CLIVEDEN ROAD, TAPLOW, MAIDENHEAD,
BUCKINGHAMSHIRE, SL1 8NS

BUCKINGHAMSHIRE

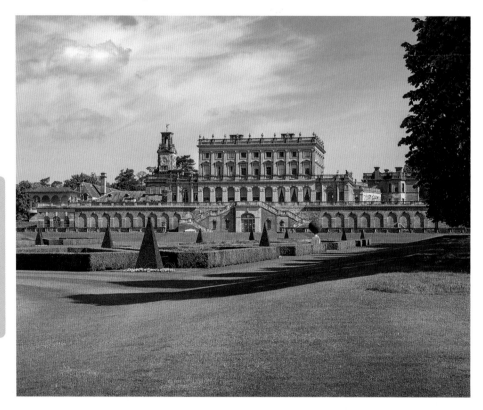

Set high above the Thames, elegant and striking Cliveden has long attracted the famous and infamous. Nancy Astor, the first female MP to take up her seat at Parliament and wife of Cliveden's then owner, Waldorf Astor, held lavish house parties here in the 1930s; Winston Churchill, George Bernard Shaw and Charlie Chaplin were frequent guests. The 1960s brought the house worldwide fame due to its part in the Profumo Affair; Christine Keeler first met John Profumo here while having a dip in the swimming pool. The house is now a hotel but parts of it are open to visitors.

Sherlock Holmes (2009) 🎥
Directed by Guy Ritchie; starring Robert Downey Jr., Jude Law, Rachel McAdams

Guy Ritchie's comedic take on the sleuthing genius, with added bare-knuckle fighting, arrived for two days filming at Cliveden in November 2008. The film's authentic Victorian look was pieced together using locations as diverse as Manchester, Chatham, Liverpool, London and New York City. Cliveden's French Dining Room (see opposite) plays Irene Adler's hotel room at the Grand Hotel; she meets Holmes there and events soon take a rather drastic turn. William Waldorf Astor, the first Astor to own the house, had the room brought over lock, stock and barrel from the

"Madam. I need you to remain calm and trust me, I'm a professional, but beneath this pillow lies the key to my release."

Sherlock, speaking to the chambermaid who discovers him.

Chateau d'Asnières, outside Paris. And they say you can't buy taste.

The carpet and most of the furniture in the film were props. It's usual practice for the lighting team to bring light from the outside in through the windows, and they did so here – building three external scaffolding towers from which the lights were hung. The lighting towers were put on boards to protect the grass and nothing was fixed to the stonework of the building.

Guy Ritchie and Robert Downey Jr. could be seen relaxing in the Great Hall between shots and the military-level logistical planning meant that the hotel functioned as normal while the filming took place.

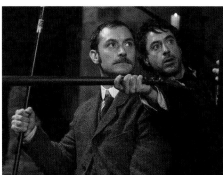

ABOVE The French Dining Room.

RIGHT Robert Downey Jr. and Jude Law in character as Holmes and Watson.

BELOW Sherlock Holmes and a pillow.

Hampstead (2017) 🎥

Directed by Joel Hopkins; starring Diane Keaton, Brendan Gleeson, James Norton

ABOVE **Ferry Cottage.**

BELOW **Emily (Diane Keaton) at the cottage.**

The story follows two Hampstead residents, recently widowed Emily, played by Diane Keaton, and Donald (Brendan Gleeson), who lives in a ramshackle home on the Heath. Most of the film was shot in the lovely cobbled lanes of Hampstead village and on its Heath. The crew, however, journeyed out of London to shoot the end of the film at the National Trust-owned holiday hideaway Ferry Cottage, a two-bedroom house on the Thames riverside within Cliveden's sprawling estate. The filming took place over two days and required an acting cockerel which arrived with its very own wrangler. For some shots, and this was a National Trust first, the crew placed a crane on a floating pontoon on the river and filmed from there.

In these scenes we learn that Emily has moved out of London and found that a quieter country life suits her very well. It's safe to say that Diane was also a fan saying, '. . .everybody should go [to Ferry Cottage]; it couldn't have been more idyllic'. High praise indeed from the

Oscar winner and the good news is you can go: as a holiday cottage it is available to rent. Cockerel optional.

Also filmed at Cliveden: *Help!* (1965), *Carry On: Don't Lose Your Head* (1967), *Chaplin* (1992), *Carrington* (1995), *Thunderbirds* (2004), *Mrs Henderson Presents* (2005), *Made of Honour* (2008), *Mr Selfridge* (TV, 2013–2016), *A Little Chaos* (2014), *Cinderella* (2015), *Mothering Sunday* (2021), *The Bubble* (2022)

STOWE
BUCKINGHAM, BUCKINGHAMSHIRE, MK18 5EQ

Stowe is a garden lover's paradise, comprising hundreds of acres of delight and wonder in the form of lakes, follies and sweeping views. Much of the garden we see today was created by Lancelot 'Capability' Brown in the mid-eighteenth century.

ABOVE Olivia Colman on set at the Temple of Ancient Virtue.

The Crown (2016–) 📺
Directed by various; starring Olivia Colman, Tobias Menzies, Helena Bonham Carter

While **Woodchester Park** received its royal visit in *The Crown's* second series, Stowe had its turn in the third, in which this irresistible peek behind palace walls covered the mid-1960s to the mid-1970s. This required a brand-new cast as, by now, the Queen, Prince Philip and Princess Margaret had moved into their forties. Olivia Colman and Tobias Menzies took over as the Queen and Prince Philip, with Helena Bonham Carter playing Princess Margaret.

Stowe's Temple of Ancient Virtue appeared as a mausoleum at an Amiens battlefield. Filmed on one late December day, prop gravestones, flowers and wreaths were added to give it the required look. Ninety-four supporting artists were on site, as well as Olivia Colman. Some scenes were also filmed at Stowe School (not National Trust) which occupies Stowe House within the landscaped gardens.

The World Is Not Enough (1999) 🎥

Directed by Michael Apted; starring Pierce Brosnan, Sophie Marceau, Robert Carlyle, Judi Dench, Desmond Llewelyn

The National Trust has hosted another iconic Brit at Stowe – James Bond. In Pierce Brosnan's third outing as the super-smooth spy, Bond has to save the world from nuclear disaster while protecting an oil tycoon's daughter and dodging an evil nemesis, Renard.

Despite being pretty busy and no doubt dealing with killer Martini hangovers, he makes time to pop into Stowe for the funeral of Sir Robert King. The Gothic Temple provides the backdrop for this scene in which Bond is joined by M (Judi Dench) and Elektra King (Sophie Marceau). The Temple is available for holiday lets via the Landmark Trust.

Robert Carlyle is the terrifying Renard, who feels no pain, while Robbie Coltrane also appears as Russian mafia boss Zukovsky. This was Desmond's Llewelyn's final outing as Q; he'd become a much-loved Bond institution after appearing in 17 of the films.

The production company transported around twenty highland cattle from Scotland to Stowe, unaware that there were already some in the park. They must have been hiding on the recce.

For more on Bond locations, see the entry on **Holywell**.

BELOW Bond (Pierce Brosnan) and Q (Desmond Llewelyn) wait for the computer to stop buffering.

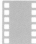 Harrison Ford was also here when *Indiana Jones and the Temple of Doom* (1984) filmed the iconic book-burning scene on the south front and lawn of Stowe School.

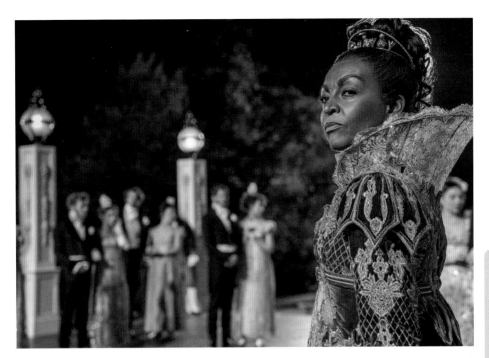

Bridgerton (2020–) 📺

Directed by various; starring Phoebe Dynevor, Regé-Jean Page, Jonathan Bailey, Adjoa Andoh

ABOVE Lady Danbury (Adjoa Andoh) awaits the fireworks.

When *Bridgerton* first enquired about filming at Stowe, the Trust had no idea how popular the show would become. Landing on Netflix on Christmas Day 2020, within a month 82 million households had streamed in to watch the adaptation of Julia Quinn's novels about Georgian high society.

The show wanted to recreate the Vauxhall Pleasure Gardens, an area of London whose evening parties served as a Georgian version of Tinder. The scenes were pivotal in the first episode, when Regé-Jean Page, playing eligible bachelor number one Simon Basset, the Duke of Hastings, dances and plots with Daphne Bridgerton, played by Phoebe Dynevor.

Noted for its glorious use of colour in costume, epic sets and flowers, this episode was no exception. A staggering 170 supporting artists were required alongside the principal actors and 150 crew; all of whom had to be parked, fed and watered, as well as dressed regally.

The Temple of Venus provided the backdrop for the dancefloor and a spectacular firework display, involving 400 fireworks as well as 30 flambeaux and over a mile of festoon lighting, all of which took the 50-strong prep crew five days to put in place. Fireworks depend on good weather, in particular the wind. To avoid any potential fire risks, and make sure nearby wildlife stayed out of harm's way, plans were drawn up to judge where they might land. Happily, everything went well on the night.

Pegg's Terrace, the Palladian Bridge and Queen Caroline's Statue can also be spotted.

For more Bridgerton, see **Petworth** and **Basildon Park**.

Also filmed at Stowe: *Stardust* (2007), *The Wolfman* (2010), *Pan* (2015), *Pride and Prejudice and Zombies* (2016), *Britannia* (TV, 2018–2021)

71

CLAYDON

MIDDLE CLAYDON, NEAR BUCKINGHAM,
BUCKINGHAMSHIRE, MK18 2EY

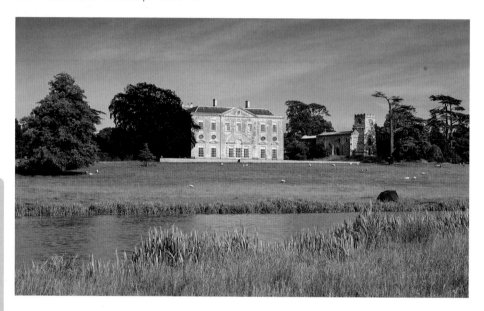

Claydon is surrounded by extensive, unspoilt parkland and was built between 1757 and 1771 by Ralph, 2nd Earl Verney. Behind the simple Georgian exterior lie some of the eighteenth century's most opulent and remarkable interiors.

Far From the Madding Crowd (2015) 🎬

Directed by Thomas Vinterberg; starring Carey Mulligan, Michael Sheen, Matthias Schoenaerts, Tom Sturridge

In November 2013 a 'madding crowd' of well-dressed Victorians arrived at Claydon for a Christmas ball. Thomas Hardy's beautiful and headstrong heroine Bathsheba Everdene (Carey Mulligan) dances with dashing shepherd Gabriel Oak (Matthias Schoenaerts) while her wealthy neighbour William Boldwood (Michael Sheen) enviously looks on. Later, at the front of the house, tragedy strikes and their lives change forever.

Claydon, both inside and out, starred as Boldwood House in this adaptation of the classic novel. As home to William Boldwood, the location needed to contrast with Bathsheba's working farm. Claydon's grandeur and elegance fitted the bill.

The grounds were also ideal, as the film's location manager Alex Gladstone said: 'The lack of neighbouring buildings or main roads meant that you felt as if we had stepped back in time as soon as you turned into the drive.' It was also deemed worth the 130-mile move from Dorset, where the rest of the shoot took place. Even the estate's cows were perfect and graciously agreed to appear as themselves.

The ballroom scene in the Saloon took a significant amount of planning and three days to set up. Eighty crew and their equipment would need to fit in along with seventy-five supporting artists, eight cast members, a huge Christmas tree, prop furniture and a long table of food.

Candles on candelabra, always needed for period films, were brought in ready for takes.

To minimise smoke, these are only lit when the cameras are actually rolling – a crew member stands just out of shot and leaps in with the snuffers as soon as 'cut' is called. This means minimal smoke reaches the ceiling and also helps the art department as the candles stay the right height for continuity purposes.

The extensive food list included a huge range of fake and real food including pies, Christmas puddings, roast meats, biscuits, cakes, jellies, pomegranates and an exotic delicacy at the time – a pineapple. Ball guests are seen marvelling at its oddness! Neither red wine nor berries were allowed, a National Trust condition, in case of any spillages onto the floor. The filming took place over two nights, from 7pm to 5am, to make the most of the darkness. Rather tiring for the Trust staff on duty but the spectacle more than made up for it.

Actors needed to be seen on the main staircase, but this presented a problem as Claydon's is very delicate and to protect it

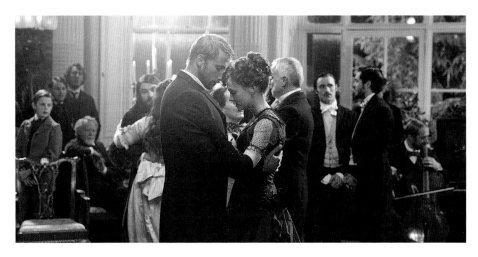

ABOVE Carey Mulligan as Bathsheba Everdene and Matthias Schoenaerts as Gabriel Oak in the Saloon.

LEFT Filming outside the front of the house; the clad visitor reception building can be seen (centre) along with the scattered fake snow.

 The Trust owns Hardy's Cottage in Higher Bockhampton, Near Dorchester, where the author was born and where he wrote *Far From the Madding Crowd*.

it's no longer used. It is the most important staircase in the National Trust's care: the steps are mahogany, inlaid with ebony and ivory and the intricate metalwork balustrade features sheaves of wheat that were designed to make the sound of rustling wheat as you climb up or down. The Trust decided the only way to make this work was for the actors to wear very soft-soled shoes if their feet were in shot and socks if they weren't. The corresponding sound effects were added later. The film crew were relegated to the back stairs.

Outside, at the front of the house, a night-time winter wonderland was created. The visitor reception building was impossible to move or hide so it was made to look like a snow-covered outbuilding. Biodegradable fake snow was scattered, a large Christmas tree was put to one side of the front door and gas-fired braziers lit the scene. In the film, the ball is interrupted by a gunshot, so the real-life local police were informed; this is standard practice when firearms are used on location – whether or not they are fired.

Claydon's Library features as Boldwood's study and the upstairs bedroom where Bathsheba discovers the clothes and jewels Boldwood has bought for her is in fact the Gothic Room.

LEFT AND BELOW The crew preparing for filming in the Library (below) and the scene as it looked on screen (left).

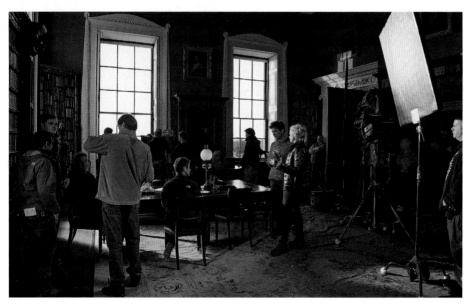

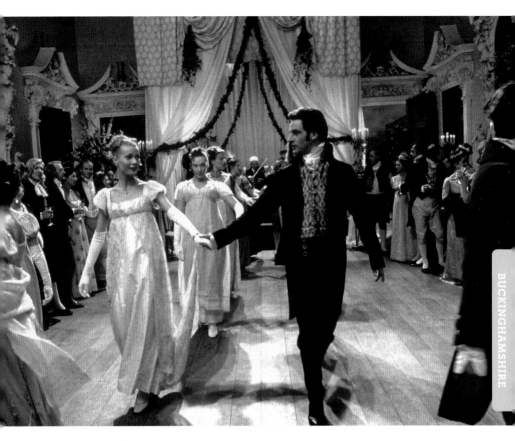

BUCKINGHAMSHIRE

Emma (1996) 🎥
Directed by Douglas McGrath; starring Gwyneth Paltrow, Toni Collette, Jeremy Northam

ABOVE Filming in the North Hall; Gwyneth Paltrow as Emma and Jeremy Northam as Mr Knightley.

Nearly twenty years before, another ballroom scene was filmed at Claydon when Gwyneth Paltrow played the self-styled matchmaker extraordinaire in this big screen outing of Jane Austen's novel. This time it was the turn of the distinctive yellow and white North Hall which stood in as the ballroom at the Weston's home, Randalls. It's at this ball where Emma, having neglected her own love life, begins to realise her true feelings for Mr Knightley. The stage for the band helpfully concealed a mirror – always a problem for film crews. Emma's neighbour Miss Bates arrives and says the room is 'just like a fairy-tale'. Go and visit and you might well agree.

Also filmed at Claydon: *Glorious 39* (2009), *The Aeronauts* (2019), *Cinderella* (2021)

Florence Nightingale was a frequent visitor to Claydon as Parthenope, wife of Sir Harry Verney, 2nd Baronet, was her sister. During the filming of *Far From the Madding Crowd* her bedroom was used as a green room for actors.

ASHRIDGE ESTATE
NEAR BERKHAMSTED, HERTFORDSHIRE

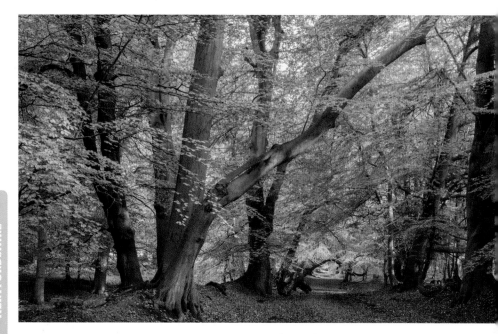

The Ashridge Estate is an Area of Outstanding Natural Beauty (AONB). Crossing the Chiltern Hills the Estate encompasses 2,000 hectares (4,942 acres) of beech and oak woodland as well as rolling chalk downland and meadows. With such a variety of landscapes and being close to the major London studios, Ashridge has always been popular with film-makers. The earliest filming of which the Trust has a record was here in 1947; as the equipment of the time was large and cumbersome it must have been quite an effort. Ashridge is also the most filmed location the Trust has, never portraying itself but becoming, among other things, a foreign field or a fictional or magical land.

Harry Potter and the Goblet of Fire (2005), Harry Potter and the Half-Blood Prince (2009), Harry Potter and the Deathly Hallows: Part 1 & Part 2 (2010 & 2011) 🎬◀
Directed by Mike Newell, David Yates; starring Daniel Radcliffe, Emma Watson, Rupert Grint

Harry Potter and The Goblet of Fire was the fourth Harry Potter film and follows another difficult year at school when he has to enter the Triwizard Tournament. This was the first 'Potter' film to be given a 12A certificate as it is darker in tone than its predecessors.

A distinctive beech tree in Frithsden Beeches, part of the Ashridge Estate, was used in *Harry Potter and the Goblet of Fire*. Contrary to popular myth this one was not the Whomping Willow but it did feature in the scenes where Harry and his friends, the Weasleys, are heading to the Quidditch World Cup. On their way, they bump into Cedric

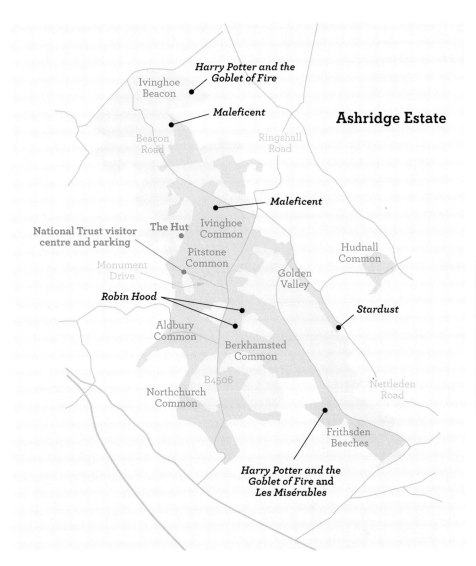

Harry Potter and the
Goblet of Fire

Ivinghoe
Beacon

Maleficent

Ashridge Estate

Beacon
Road

Ringshall
Road

Maleficent

National Trust visitor
centre and parking

The Hut

Ivinghoe
Common

Monument
Drive

Pitstone
Common

Hudnall
Common

Golden
Valley

Robin Hood

Stardust

Aldbury
Common

Berkhamsted
Common

B4506

Northchurch
Common

Nettleden
Road

Frithsden
Beeches

Harry Potter and the
Goblet of Fire and
Les Misérables

Diggory (Robert Pattinson) and his dad. Cedric is hiding up the Frithsden tree when they meet.

To get to the match, Harry and his friends must find a 'Portkey' so they climb Ivinghoe Beacon, also part of the Estate, during their search. The Portkey is in the shape of a manky old boot. In the next scene they are at the top of the distinctive white cliffs at Seven Sisters in Sussex, parts of which are owned by the National Trust (Cuckmere Haven and Birling Gap). The Quidditch match itself was shot in the studio and combined scenery from Scotland with computer imagery.

Sadly, in 2014 the famous tree that had also appeared in *Sleepy Hollow* and *Les Misérables* came to the end of its life. It was centuries old and weakened by fungi; almost groaning under its own weight the tree split in half. It was left in situ to continue to support dead wood invertebrates which are an important part of Ashridge's ecosystem.

The 'plate shot' technique allows Ashridge and Ivinghoe Beacon to appear in *Harry Potter*

LEFT Cedric Diggory
(Robert Pattinson) and
his dad Amos Diggory
(Jeff Rawle).

and the Half-Blood Prince and Harry Potter and the Deathly Hallows: Part 1 & Part 2. See the **Lavenham Guildhall** entry for more detail on the technique.

Harry Potter and the Deathly Hallows: Part 1 also filmed at **Hardwick** and **Lavenham Guildhall**; Parts 1 and 2 filmed at **Freshwater West and Gupton Farm**; Harry Potter and the Half-Blood Prince also filmed at **Lacock Village**.

Stardust (2007) 🎥

Directed by Matthew Vaughn; starring Charlie Cox, Sienna Miller, Robert De Niro

A wall was built in the Ashridge Estate's Golden Valley to create a border with the mysterious magical kingdom of Stormhold. On the other side is the fictional English village of Wall. Our hero Tristan enters Stormhold to catch a falling star as a present to his girlfriend (Boots was closed presumably) played by Sienna Miller. However, the fallen star turns out to be a woman called Yvaine who is being pursued by feuding princesses and witches. Flying pirates are also involved as were Mark Strong and Michelle Pfeiffer.

The original plan for building the wall had to be abandoned after the film-makers saw how large the Valley actually is. It's hard to make something impressive when the Valley itself is awesome. The 60-metre (197-foot) 'cobblestone' wall took about three weeks to build and looked like a massive dry stone wall; there was a large gap in it, as if a giant sheep had knocked it down. This was the route into the kingdom. While the wall was being built the roads through the Estate had to be kept open as they are vital for the local villages and businesses. Because Trust land is often designated for nature conservation objectives, the film crew were given strict instructions on how the wall should be built and secured, and the Valley protected.

The shoot was hampered slightly by rain and a planned coach chase could only take place once Trust staff had inspected the ground for the potential damage from horses and carriage wheels. Permission was granted but as chases go this one was a tad slow. A helicopter was also flown over the Estate to show off the grandeur of Stormhold; this was combined with footage from the Isle of Skye and Iceland to piece together a magical kingdom. A local micro-brewery produced

a Stardust beer to celebrate the shoot. According to the film, eating stardust brings eternal youth and beauty – unlikely that the beer does the same.

Les Misérables (2012)
Directed by Tom Hooper; starring Hugh Jackman, Russell Crowe, Anne Hathaway, Eddie Redmayne

The film-makers of 'Les Mis' – previously a stage show, based on the novel by Victor Hugo – arrived at Ashridge, looking for 'a field outside nineteenth-century Paris'. Like the crew from Harry Potter they were drawn to Frithsden Beeches and the now deceased centuries-old beech tree with its 25-metre (82-foot) span.

The story concerns ex-convict Jean Valjean and his experience of redemption. As might be suspected from a novel of 1,500 pages there are many subplots. The scene filmed at Ashridge is where Valjean meets Cosette, the daughter of the deceased Fantine, whom he has promised to care for. Cosette is played by 10-year-old Isabelle Allen making her acting debut and looking remarkably like the girl in the poster of the all-conquering musical (39 years in the West End so far).

For this scene, an area of about a thousand square metres would be in shot and all of it needed to be covered in artificial snow. Like train companies the Trust doesn't like the 'wrong sort of snow' and the preferred materials for artificial snow are eco-friendly: pure cellulose based on either wood or paper. The material is applied on top of a membrane which allows water and sunlight to pass through, and means that the 'snow' can be shovelled up like real snow afterwards. This careful process is vital when the site is a Site of Special Scientific Interest (SSSI).

On the night of the shoot the actors didn't need snow to convey winter as the weather was freezing. Famously, all singing by the cast was performed live.

BELOW Jean Valjean (Hugh Jackman) looking for a new barber.

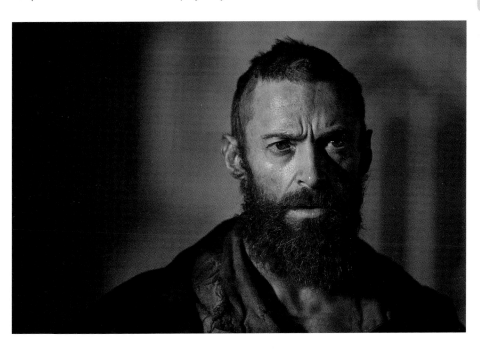

RIGHT Angelina Jolie
on set.

BELOW The *Maleficent*
set deep in the Ashridge
woodland.

HERTFORDSHIRE

Maleficent (2014) 🎥

Directed by Robert Stromberg; starring Angelina Jolie, Sharlto Copley, Elle Fanning

Maleficent is the wicked witch in *Sleeping Beauty*, the 1959 Disney film. She is living in a magical forest kingdom called The Moors and is fighting off King Henry who is trying to take over.

Once again if you want a magical kingdom then Ashridge is the place to be. As the film's location manager Bill Darby said, 'People think you can create almost any image with a computer these days, but we are not quite there just yet, and the successful combination of reality and fantasy in film-making is an art form in itself. *Maleficent* is a celebration of that form, in which Ashridge Estate plays an integral part.'

The crew still needed green screen to add perspective to the forest. A green, or in this case blue, screen is constructed at the location to mark where eventually backdrops will be added later using visual effects technology. The plot involved fight scenes so several days were spent with stuntmen and stuntwomen suspended on wires and rigs, being thrown into the air and bounced from trampolines. The wires were removed or 'painted out' later by a computer. On one day the sun shone through

the trees and onto the artificial snow and set; a director of photography would have spent days trying to re-create such a beautiful effect.

A security fence was put around the set in order to conceal it but given the size of the Estate and the locals' unconcern at the presence of film crews – who are seen there so often – the fence proved pointless.

Maleficent was also shot at **Petworth** in Sussex where the park was used to film charging horses, for incorporation into the battle scenes.

Robin Hood (2010) 🎥

Directed by Ridley Scott; starring Russell Crowe, Cate Blanchett, Mark Strong

Not only did Ridley Scott pick **Freshwater West** for his retelling of the legend of Robin Hood he also picked Ashridge like many directors before him. The story is legendary of course but in this case the plot was about Robin and his band leading an uprising against the crown.

Ashridge was used as a village in which Robin stops on his way to London. This time part of the Estate known as Thunderdell Wood was chosen. Although it represented only a small part of the film, the shoot was still complex: small huts had to be built as well as the 'road to London', and the cast and crew numbered six hundred. The production was at Ashridge for four months, though there were only six days of shooting. As always with such a massive team, some work had to be done beforehand: potholes filled, trees trimmed so trucks could gain entrance, fences removed and visitor signage taken down. The production designer also wanted to add some greenery to enhance the wooded area. The National Trust either provides its own greenery – usually from another part of the Estate – or allows only sterile plant life or artificial greenery for bio-security reasons.

On days when the crew might be filming elsewhere, called 'hold-days', the set is left and only the crew's camera and lighting etc equipment is removed. Security is then on-site, not to stop fans so much but to make sure the set looks exactly the same for continuity. Nothing can be allowed to delay filming on a shoot day; time really is money.

This shoot was relaxed as everyone had worked together before on other films. Russell Crowe was even kind enough to invite the hard-working National Trust staff to a BBQ where it is rumoured singing took place.

The final National Trust location to receive *Robin Hood* was Dovedale in the Peak District. The crew used an area of this stunning landscape which stretches down to Dovedale's famous Stepping Stones across the River

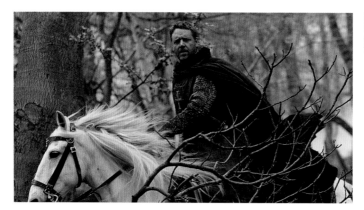

Dove. The scenes involved 140 men on horses and took two days to film although a month had already been spent organising stabling for the horses. The rest of the crew took the numbers up to seven hundred. Families visiting Dovedale for a walk were surprised to find an army in chain mail passing by. They were even more stunned when Russell Crowe popped over to say hello and sign autographs.

Also filmed at the Ashridge Estate: *The Dirty Dozen* (1967), *First Knight* (1995), *Sleepy Hollow* (1999), *Enigma* (2001), *Alfie* (2004), *The Descent* & *The Descent: Part 2* (2005 & 2009), *Lewis* (TV, 2006–2015), *Children of Men* (2006), *Son of Rambow* (2007), *Hot Fuzz* (2007), *Cranford* (TV, 2007 & 2009), *Primeval* (TV, 2007–2011), *The Other Boleyn Girl* (2008), *Into The Woods* (2014), *The Hollow Crown, Series 2: Henry VI Part 1 & Part 2, Richard III* (TV, 2016), *Britannia* (TV, 2017–2021), *The Little Drummer Girl* (TV, 2018), *Killing Eve* (TV, 2018–), *Baptiste* (TV, 2019–2021), *Dr Dolittle* (2020), *Enola Holmes* (2020), *Bridgerton* (TV, 2020–), *Cruella* (2021), *Slow Horses* (TV, 2022–), *The Ballad of Renegade Nell* (TV, 2023–), *My Lady Jane* (TV, 2024–)

Ashridge – The Hut

Hidden away in the Estate is a small scout hut, log cabin or hunting lodge depending on your viewpoint. It's also the hardest working shed the Trust owns and has appeared in more films than most actors. It has no obvious purpose but is built in the style of a Canadian log cabin and looks like it should be full of lumberjacks or hikers. Not only does it save a film crew the bother of flying to Canada, Norway, USA etc., the interior is conveniently empty and has an odd faux-wooden plank décor. Production designers love a 'blank canvas' and of course it doesn't involve the usual conservation considerations.

The hut appeared in the cult horror film *The Descent* and its sequel. In the first film a group of women use the hut before an ill-advised caving trip. This was Ashridge standing in for North Carolina. The hut has been in the TV detective show *Lewis* as a moody place to hide a body. In *Primeval* it was cleverly configured as an explorer's hut in a remote forest, and trashed by dinosaurs. It also popped up in *The Little Drummer Girl*.

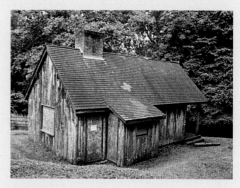

FRENSHAM LITTLE POND

PRIORY LANE, FRENSHAM, SURREY, GU10 3BT

Frensham Little Pond was created in the thirteenth century as a fishing pond for the Bishop of Winchester. It is home to rare birds, such as the reed bunting, sedge warbler and great crested grebe. The banks of the pond are fringed with common reed and a variety of wetland plant species.

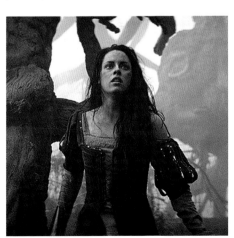

Snow White and the Huntsman (2012) 🎥

Directed by Rupert Sanders; starring Kristen Stewart, Chris Hemsworth, Charlize Theron

The Huntsman: Winter's War (2016) 🎥

Directed by Cedric Nicolas-Troyan; starring Chris Hemsworth, Charlize Theron, Emily Blunt

How do you build a village on a Site of Special Scientific Interest (SSSI), and then burn it down? The answer is, very carefully. There were parts of the land where no filming at all could take place and parts where it was possible with stringent conditions and constant monitoring. For instance, on the fishing village set the piers could not be anchored into the lake bed but were instead were floated and kept in place with weights. The village took two and half months to build

LEFT Kristen Stewart as Snow White in *Snow White and the Huntsman*.

83

with the shoot itself taking nine days. Working with Natural England, the National Trust produced an Environmental Impact Report which helped minimise the effects of the shoot.

When it came to creating the fire, the whole set was laid with pipes and worked like a massive gas hob. At the right moment, the gas was lit and each and every building appeared to be on fire while stuntmen fought and horses reared. As soon as the scene was over the 'fire' was switched off by turning some valves. Naturally all of the buildings were made of fire-retardant materials but a real fire brigade was part of the five-hundred-strong crew just in case.

The fee for the shoot allowed the National Trust to carry out essential work to protect Frensham, including the installation of revetments which prevent the banks of the

pond eroding. The local community benefited from the shoot too, especially film production students from the University for the Creative Arts in Farnham, who were able to tour the set and meet the cast and crew.

The film is based on the Brothers Grimm story: the Huntsman is sent to kill Snow White but instead becomes her protector against the evil Queen. However, the complex film plot bears little resemblance to the famous Disney version. Although there are dwarves, they are more warrior-like than comedic; they are played by a batch of British character actors including Toby Jones, Ian McShane and Bob Hoskins.

In the sequel there was no burning to be had but a smaller village was built and there were new additions to the cast, including Jessica Chastain, Rob Brydon and Sheridan Smith.

Filming also took place at Cathedral Rock in the Lake District and Marloes Sands and Mere in Pembrokeshire, Wales, where the crew spent a week filming the Huntsman and his troops charging along the beach on horses during an epic battle. The Gothic castle was added on later with visual effects.

Also filmed at Frensham Little Pond: *The Witcher* (TV, 2019–), *The Eternals* (2021), *The Lord of the Rings: The Rings of Power* (TV, 2022–), *The Ballad of Renegade Nell* (TV, 2023–), *The Power* (TV, 2023–)

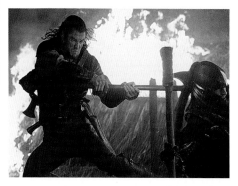

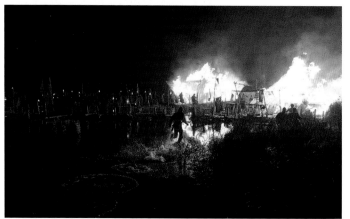

ABOVE The Huntsman (Chris Hemsworth) in action.

LEFT The 'fire' could be seen from as far away as Guildford.

PETWORTH

PETWORTH, WEST SUSSEX, GU28 0AE

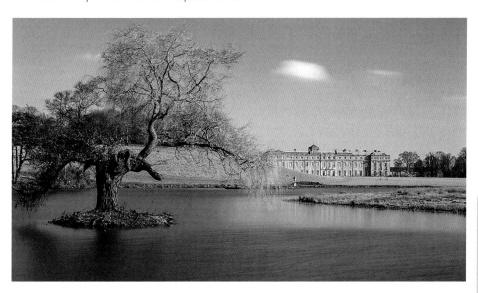

Still a family home after more than nine hundred years, Petworth was a royal gift from the widow of Henry I to her brother Jocelin de Louvain, who later married into the renowned Percy family. The family was put under house arrest by Elizabeth I, which prompted them to begin the expansion of the medieval building.

Mr Turner (2014) 🎥
Directed by Mike Leigh; starring Timothy Spall, Lesley Manville, Ruth Sheen

Petworth contains a famous art collection and is the only place in the world where you can look at a Turner landscape and then glance out of the window to see that very same landscape. This explains why Mike Leigh, who was finally making his long-cherished film about J. M. W. Turner, was so keen to film there. The house had been the home of George Wyndham, 3rd Earl of Egremont and one of Turner's patrons who had bought 20 of his works. Turner was allowed to turn the Library into his studio and this was re-created for the film.

Mike Leigh is well known for allowing his actors to improvise and develop a script, but also to be inspired by locations. After rehearsals in the local town hall and once the house was closed to visitors, the cast were given access to Petworth. Three days of rehearsal in the house was then built into the schedule.

Leigh was also keen to light the house as it would have been in the nineteenth century; many candles were carefully placed and lit for a scene depicting an evening music salon in the Carved Room. Needless to say this only happened after meticulous planning and requisite precautions had been set up.

Daytime filming was much simpler. As Mike Leigh said, 'Petworth is very special for its light and the sun does exactly the same thing as it did in 1823.'

Although almost every state room was used there was special attention paid to the room Turner used as his studio. There is a scene where Timothy Spall, who plays Turner, is seen painting a landscape, the eye of the camera

acting as the frame of the original painting, *The Artist and his Admirers*.

To coincide with the film's release, Petworth held a three-month exhibition which included Turner's originals in the house as well as props and costumes from the film, plus paintings done by Timothy Spall, and culminated in a filmed interview with Mike Leigh. This ended with a scene from the film where Lord Egremont's niece and friends rush up the staircase and burst into the studio to see Turner at work. Especially for the exhibition, and only for its duration, the visitor had the chance to re-enact that scene and find the studio exactly as it was in the film – although without Timothy Spall. Mike Leigh and Timothy Spall kindly opened the exhibition in January 2015.

Mr Turner also shot at the National Trust's Dovedale in the Peak District and Cwm Idwal in Wales.

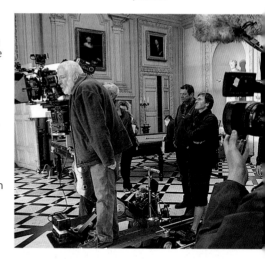

BELOW Mike Leigh and his crew at work in the Marble Hall.

BOTTOM Mike Leigh directs in another part of the house, the Old Library (not open to the public).

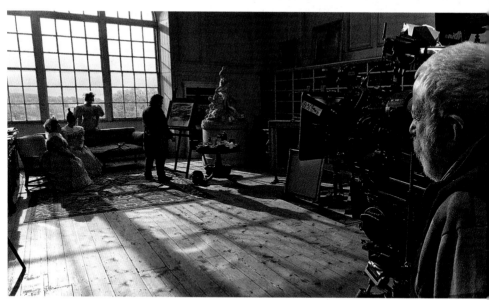

“ *The shot of Turner painting a woman and two girls in the Old Library is an exact replica, even colour-wise, of The Artist and his Admirers ... to be in the very room where Turner painted this scene, to be inside that painting, was an astounding privilege.* ”

Timothy Spall

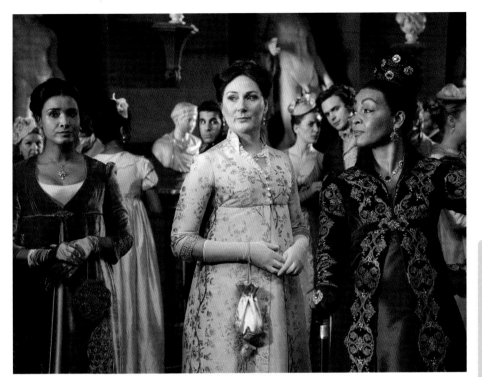

Bridgerton (2020–) 📺
Directed by various; starring Adjoa Andoh,
Ruth Gemmell, Shelley Conn

ABOVE Lady Mary Sharma, Dowager Viscountess
Bridgerton and Lady Danbury survey the scene in
Petworth's North Gallery.

Needing an art gallery for the second series of
Bridgerton, the location manager set out to
find one that wouldn't require closing a
national museum. Also, where would you park
the trucks? As home to one of the National
Trust's finest art collections, Petworth's North
Gallery and Red Room were ideal, meaning
they could go light on the props as nearly
everything they needed was already there.

A particular statue and plinth were key to
the storyline so were brought in by the art
department. To make way for these the Trust
had to move a delicate and important
collection piece, the Molyneux globe. Dating
from 1592, the piece has an incredible history.
Built by mathematician Emery Molyneux and
decorated with sea creatures, boats and an
elephant, it is one of the first English globes.
Two specialist conservators were brought in to

handle this move. Other prep work involved
the local team contacting lenders to clear the
use of several paintings and removing a large
one by Northcote. All in all, a fair task for one
day's filming.

As the scenes showed the 'ton',
Bridgerton's high society members, mingling
in the Gallery, it involved 80 supporting artists
as well as 29 cast and 150 crew.

To prevent petty pilfering by Petworth's
700-strong herd of fallow deer, the crew were
asked to ensure no food was left in the dining
marquee overnight.

For more *Bridgerton* see **Stowe** and
Basildon Park.

Also filmed at Petworth: *Rebecca* (2020),
Napoleon (2023)

LAMB HOUSE

WEST STREET, RYE, EAST SUSSEX, TN31 7ES

Lamb House was built in 1722 and can be found nestled among the cobbled, winding streets of historic Rye. The walled garden is the largest in the town and boasts wide flower beds, a large lawn and quiet hidden corners. The house has strong literary connections as both E. F. Benson, author of the Mapp and Lucia series of books, and Henry James have called it home.

Mapp and Lucia (2014) 📺

Directed by Diarmuid Lawrence; starring Anna Chancellor, Miranda Richardson, Steve Pemberton, Mark Gatiss

Never had the words 'au reservoir' been as frequently uttered in one place as they were at Lamb House in summer 2014. Mapp and Lucia had arrived on site and this was Miss Mapp's favourite catchphrase. The house was playing 'Mallards', Miss Mapp's home, leased to Lucia for the summer, in this three-part BBC drama.

The books were written by E. F. Benson in the 1930s and focus on the townsfolk of Tilling, based on Rye, and their various battles for social supremacy as well as their catchphrase one-upmanship. The author lived in the house and based Mallards on his own home, so Lamb House and Rye were both, effectively, playing themselves. As film sets go, the location was second to none when it came to authenticity.

The location manager, Henry Woolley, explained the benefit of using the actual setting of Benson's tales: 'When I discovered that Benson's fictional town of Tilling is based on Rye and that Mallards is based on Lamb House, it didn't take me long to find out that both Rye and Lamb House are pretty much the same as ever they were.'

E. F. Benson was very happy in Rye and even went on to become the town's mayor so it's no surprise he didn't want to stray far from home for inspiration. He's buried at St Mary's Church just a few steps away from the house.

Very nearly all of the show was filmed in

ABOVE LEFT Anna Chancellor (Lucia) and Miranda Richardson (Mapp) in the garden.

ABOVE RIGHT A well-thumbed copy of the script.

LEFT The specially constructed garden-room at the back of the house.

Rye and a total of five weeks of filming took place at Lamb House – about 75 per cent of the overall shoot. A house that had previously only hosted a few small documentaries suddenly found itself a hive of activity when the fifty-strong crew, the usual stacks of equipment and a host of famous faces settled in for the summer. It was in fact one of the longest periods of filming the National Trust has ever hosted.

Nearly every ground-floor room and all parts of the pretty walled garden would be used for filming. *The League of Gentlemen's* Steve Pemberton wrote the scripts and starred

as Georgie alongside Anna Chancellor as Lucia and Miranda Richardson as Miss Mapp.

Despite the house already being 'Mallards', the art department needed to carry out two weeks of work to take it back eighty years. The bulk of this work was the construction of a large 'garden-room'. It was there in Benson's day but destroyed by a bomb in the Second World War. The room plays a key part in the script as Lucia uses it for social gatherings and its window serves as a vantage point for one of her favourite activities – seeing what her neighbours are up to.

The art department explained that they'd need to build this in two parts: the vantage point window would be built onto a flat wall at the front of the house facing the road, while the room's interior, a sizeable 8m x 5m, would be built separately in the back garden, leading off the Dining Room. Using clever editing this helped create the on-screen illusion of one large garden-room with a view onto the street.

Anna Chancellor playing Lucia could only appear in the garden-room window by climbing into the constructed area via a secret panel, disguised as brickwork, underneath the window frame. The art department replaced the 'Lamb House' sign with 'Mallards' for the duration; the 'No Parking' sign at the front had to be removed and replaced daily.

TOP The art department work on the garden-room window.

ABOVE The completed garden-room window.

RIGHT Relaxing between takes on the street at the front of the house.

> *"One of my favourite days was when they were filming in the street outside Lamb House and I was sitting in the garden all by myself, in this amazing garden at the back of Lamb House. This is where he would have sat when he was writing his characters and coming up with these stories."*

Steve Pemberton, who wrote the scripts and starred as Georgie.

There was also much to be done inside the house. In the week before the crew arrived, the Lamb House staff got to work moving National Trust items not required in shot. These were all stored safely in the small telephone room just off the main hallway. The art department then came in with their props. Modern items such as radiator covers and thermostats were disguised.

The Entrance Hall presented a bit of a conundrum for both the art department and the National Trust as the wooden panels here are painted white which doesn't work well on camera. The room couldn't be re-painted as the original panelling would lose its crispness with the two layers of paint that would be required: one layer of the new colour and another layer of white to return it to its original state. The Trust's conservator had a think and came up with a solution that suited everyone. Following tests, low tack wallpaper was pre-painted by the crew in the desired colour and neatly applied to the central panels of the panelling. After filming it was carefully peeled off without leaving any residue.

As days of filming turned into weeks it soon became normal for the Lamb House staff to find themselves in the 1930s each day. It had become par for the course to see Anna Chancellor and Miranda Richardson in character doing yoga on the lawn; squabbling over ownership of the 'garden produce', and welcoming the whole of Tilling society (and sixty supporting artists) into the garden for a féte, with Lucia dressed as Queen Elizabeth I. All too soon it was the Trust's turn to say 'au reservoir'.

TOP Filming at the front of the house. Note the vintage Rolls-Royce.

ABOVE Steve Pemberton relaxing in the garden.

SCOTNEY CASTLE
LAMBERHURST, TUNBRIDGE WELLS, KENT, TN3 8JN

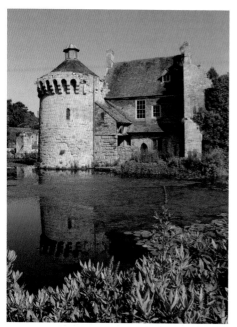

The main house at Scotney Castle was built in the mid-nineteenth century by Edward Hussey III in a valley with ancient woodland. The centrepiece of his picturesque garden is a moated island, home to a romantic medieval castle ruin.

ABOVE Asim Chaudhry as Abel and Sanjeev Bhaskar as Cain in front of Scotney's boathouse.

The Sandman (2022) 📺
Directed by various; starring Tom Sturridge, Boyd Holbrook, Patton Oswalt

We all have nightmares: the exam you haven't revised for, falling off a building, the M6. In Neil Gaiman's bestselling comic book *The Sandman*, protagonist Morpheus is the personification of such visions. He is captured in an occult ritual but escapes and sets off to restore his realm and power. Tom Sturridge took the title role, with support from other stalwarts such as David Thewlis, Jenna Coleman, Sanjeev Bhaskar and Joely Richardson, as well as Stephen Fry and Bill Patterson.

Scotney Castle was used for various scenes as the 'House of Secrets'. These included characters arriving at the castle (once the door had been altered by the art department) and dialogue in various rooms.

There was boating on the lake and some alarming action in front of the boathouse. More unusually, a graveyard was also built. A membrane was placed over all the grass on the old castle island and they also built staging underneath that to ensure that the flowerbeds were protected. Then the graves were built on top using peat-free, sterile soil and plants taken from the garden to prevent any invasive species or diseases. Prop tombstones and memorials were also added. All of this required permission from Natural England for those areas designated a Site of Special Scientific Interest (SSSI) as well as their approval of the Trust's mitigating measures. This included a pedestrian bridge being installed to replace a historic bridge that had recently been damaged and then removed.

The build took 10 days. On the shoot, smoke and rain machines completed the atmosphere. Upon its debut on Netflix, it was watched for almost 70 million hours in three days, which translates as a hit and a second series.

CHARTWELL

MAPLETON ROAD, WESTERHAM, KENT, TN16 1PS

Chartwell was Sir Winston Churchill's family home from 1922. The rooms are kept as they were when he lived there, and include paintings, books and personal mementoes. It reflects the life and work of the great statesman who was also a writer, artist and family man. Outside, the gardens reflect his love of nature and include the lakes he created and the kitchen garden.

Darkest Hour (2017) 🎥

Directed by Joe Wright; starring Gary Oldman, Kristin Scott Thomas, Lily James

Chartwell is one of the National Trust's busiest properties, attracting visitors from around the world. Playing the role of Churchill has also attracted a host of fine actors, including Richard Burton, Albert Finney, John Lithgow and Robert Hardy. Most recently, Gary Oldman in *Darkest Hour* won an Oscar for his portrayal.

Sadly, only Finney and Oldman made it to Chartwell to shoot. The property is comparatively small inside and full of paintings and artefacts, so for film-makers the space severely restricts their use of lighting and cameras. Finney made it inside for filming of *The Gathering Storm* (2002) which dealt with Churchill's pre-war backbench years. Although a great success, the actual filming did highlight the inevitable risks to the National Trust.

So, for *Darkest Hour* only exteriors could be offered. There was a scene of a motorcycle courier delivering important news. This had to be shot early in the morning as the road outside Chartwell is a busy one. The courier

then arrives at the service door which is actually the door to the National Trust office; its modern intercom had to be removed and then replaced by specialist electricians. The number of crew vehicles was kept to a minimum as the front of the house would be in shot and couldn't be used for parking. This was followed by a scene with two characters in the Rose Garden, although in the final film this appeared to take place in Westminster. Due to the season the Rose Garden was enhanced with hundreds of silk roses which were attached to the bushes.

The director, Joe Wright, had worked with the Trust before on *Pride and Prejudice* and *Anna Karenina*. Kristin Scott Thomas played Churchill's wife, Clemmie. Sir Samuel Hoare, one of Churchill's political opponents, was played by Benjamin Whitrow known for playing Mr Bennet in the BBC's famous 1995 production of *Pride and Prejudice*. Gary Oldman's performance helped the actor to a shelf-full of awards and the film to a healthy box office.

Although feature films are given limited access at Chartwell, documentaries are welcome and requests arrive from around the world. Churchill remains a source of endless fascination for viewers globally. There have been documentary films covering his life, his paintings, his relationships, his secrets and even his cat. Churchill's family have insisted that Chartwell should always be home to a marmalade cat with a white bib and four white socks and that it would be named Jock – a tradition that the National Trust are very happy to uphold.

" *A day away from Chartwell is a day wasted.* **"**

Winston Churchill on his country hideaway.

BELOW Churchill (Gary Oldman) and his secretary Elizabeth Layton (Lily James) at work in Churchill's office, actually a set built to resemble Chartwell.

KNOLE

SEVENOAKS, KENT, TN15 0RP

Knole was built as an archbishop's palace six hundred years ago but has long been home to the Sackville family. The house's art collection includes paintings by Reynolds, Gainsborough and Van Dyck as well as seventeenth-century tapestries and furniture. There are grand courtyards and acres of parkland, still populated by wild deer.

Burke and Hare (2010)

Directed by John Landis; starring Simon Pegg, Andy Serkis, Tim Curry

Knole's enclosed courtyards hide most of the 21st century and enable film-makers to show grandeur and wealth in one shot. However, for the director of *Burke and Hare* it was the less grand stableyard that caught his attention.

The scene was a public execution, not usually a laughing matter, but *Burke and Hare* is a black comedy directed by comedy legend John Landis (*An American Werewolf in London*). The story is based on the infamous nineteenth-century grave robbers who found a lucrative trade in supplying cadavers to medical students. Burke (Simon Pegg) and Hare (Andy Serkis) turn to murder when the laws of supply and demand kick in. Other comedy talents keen to work with Landis

LEFT The branded chair is a common sight on shoots.

included Paul Whitehouse, Stephen Merchant, Jessica Hynes and Ronnie Corbett.

The stableyard itself was transformed into a market square with lots of straw and mud – plus pigs, cattle, market stalls, more mud and lots of grubby peasants. Walls and drainpipes had to be made dirty. In the middle of all this, a gallows was built. Signage explained to visitors that the gallows were for a film and not the National Trust taking historical accuracy too far. Any scene with a lot of supporting artists has logistical issues. They have to be fed and watered, of course, but also put in costume very early in the day; they then spend most of the day hanging around, often in the same spot for continuity reasons. Make-up has to be re-applied and false whiskers re-glued, although in this case there was less worry about the supporting artists getting grubby.

When a crew is in a location for a number of days they often look to complete 'pick-ups'. These are small scenes that are necessary for

BELOW The hair department's travelling box of whiskers and one of the costume department's racks.

BELOW The stableyard mid-shoot and before its recent restoration. The medieval barn now has a pitched roof.

the plot but which should only take a few hours to shoot and don't warrant the expense of finding another location. Here the front courtyard gate was used for a scene outside 'prison gates', supposedly in Scotland.

The crew also shot a grave-robbing scene at West Wycombe Hill. An archaeologist supervised the careful grave-digging. Had the dig discovered anything of interest then the filming would have been stopped and another

location found – a big risk for the film-makers but the National Trust carried out research and were confident a problem-free spot had been selected, and so it proved to be. See the **Osterley Park and House** page for scenes of a blood-splattering nature.

LEFT Burke (Simon Pegg) and Hare (Andy Serkis) looking shifty.

BELOW A furry cast member.

The Other Boleyn Girl (2008) 🎬
Directed by Justin Chadwick; starring Natalie Portman, Scarlett Johansson, Eric Bana, Mark Rylance

ABOVE The crew preparing for a tracking shot.

There was less mud on this one as Knole reverted to being the house that was built to impress. Knole has a maze of roofs at different heights and chimneys of varying size and style, meaning that from a distance the roofscape looks like a small town. In this case it became Tudor London. This is a trick that other films have achieved at Knole including *Pirates of the Caribbean: On Stranger Tides*. Ironically, the house was built at Sevenoaks in Kent because of its convenient closeness to the capital.

The exterior courtyard was used as the entrance to Whitehall Palace to match various interiors shot at **Lacock Abbey.** A camera test took place to decide how the building would be lit, because there were to be a lot of night scenes. Obviously the Tudors would have made do with the moon, torches and candles but that would be useless even for a digital camera. On the other hand, over-lighting the scenes would be unrealistic for the film's audience.

Lurking in the cast were several actors who would become even more famous in the coming years: Eddie Redmayne would return to the Trust for *Fantastic Beasts: The Crimes of Grindelwald*; there was Mark Rylance pre-*Wolf Hall*; Benedict Cumberbatch who was yet to become Sherlock, and Andrew Garfield who had not yet done *Never Let Me Go* (**Ham House and Garden**), let alone become Spiderman. Eric Bana played Henry VIII. The real King Henry owned Knole and hunted here,

and it remained in royal ownership until the early seventeenth century when it came into the possession of the Sackville family.

The entrance courtyard appeared in the film *Sherlock Holmes: A Game of Shadows* where it was snowed up and then transported on-screen to a Swiss mountain castle. But the most intriguing film history at Knole are two early attempts at what would now be called pop videos. In 1967 the Beatles dropped in to shoot films for 'Penny Lane' and also 'Strawberry Fields Forever'. The mop tops were on horses for 'Penny Lane' and can be seen riding through a stone archway by the Bird House. For 'Strawberry Fields' they walk past a piano under a tree a lot. How and why this happened remains a magical mystery.

For more on *The Other Boleyn Girl*, see the entries for **Lacock Abbey** and **Great Chalfield Manor and Garden**.

Also filmed at Knole: *Pirates of the Caribbean: On Stranger Tides* (2011), *Sherlock Holmes: A Game of Shadows* (2011), *The Favourite* (2019), *Vita and Virginia* (2019), *Mary and George* (TV, 2023)

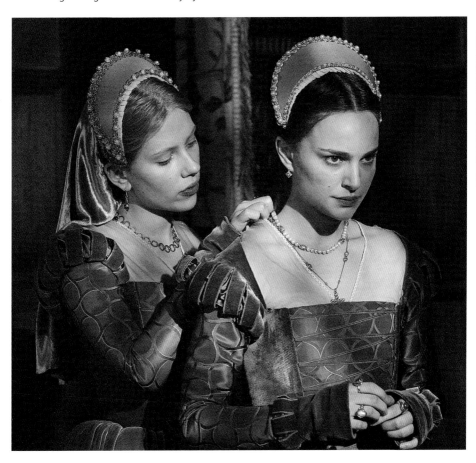

ABOVE The Boleyn sisters; Scarlett Johansson as Mary and Natalie Portman as Anne.

FENTON HOUSE AND GARDEN

HAMPSTEAD GROVE, HAMPSTEAD, LONDON, NW3 6SP

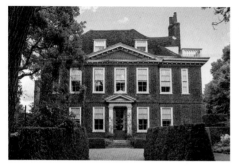

GREATER LONDON

This elegant seventeenth-century merchant's house can be found tucked away down a quiet lane in Hampstead. The inside plays host to decorative arts collections whilst the surprisingly large garden has much to offer year-round: herbaceous borders, topiary, a sunken rose garden and a 300-year-old orchard all feature. The house's top floor is worth the steps up – the views over London from the balcony are glorious.

Operation Mincemeat (2021) 🎥

Directed by John Madden; starring Colin Firth, Matthew Macfadyen, Kelly Macdonald, Johnny Flynn

The gripping film follows the true story of how two MI5 intelligence officers created an ingenious deception to outwit Nazi Germany. The plan included false maps, a corpse and counterfeit identity, and relied on a lot of good luck. Fenton was initially chosen for its garden as the high brick walls and planting were deemed a good match for those at 10 Downing Street. A scene featuring most of the main cast (sadly, not our regular Colin Firth) was shot there with fake frost and smoke machines being used to create the desired wintry look.

When the team came for a recce, they'd realised other scenes could be filmed at the property too. The house stood in for the interior of No. 10 and Churchill's office was created in the Dining Room. All contents, including a historic harpsicord, were moved out of harm's way before the crew brought in their props. Churchill did of course need to smoke a cigar, so a herbal one was used. A very sweet poodle also played a part in the scene and sat in a small basket next to his master; he was also spotted outside in the garden.

Two other ground floor rooms appeared as the home of Charles Cholmondeley (Matthew Macfadyen).

Also filmed at Fenton House and Garden: *Dancing on the Edge* (TV, 2013), *This England* (TV, 2022)

RIGHT Winston Churchill (Simon Russell Beale), Admiral John Godfrey (Jason Isaacs) and a poodle in the Dining Room.

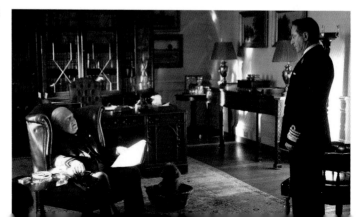

OSTERLEY PARK AND HOUSE
JERSEY ROAD, ISLEWORTH, LONDON, TW7 4RB

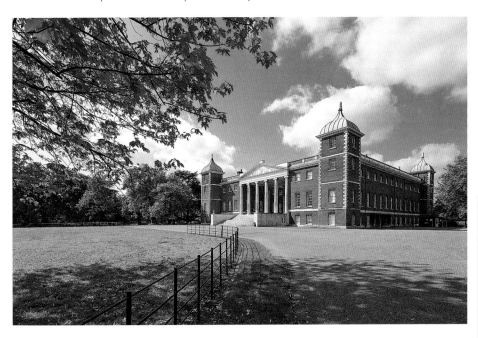

Osterley was the home of the Child banking family and remodelled by Robert Adam from 1761. Neo-classical in design with spectacular interiors, Osterley has a large estate which reflects how, when it was built, that part of west London was still countryside and an ideal retreat for the wealthy. During the Second World War the estate was a training HQ for the Home Guard.

The Dark Knight Rises (2012) 🎥
Directed by Christopher Nolan; starring Christian Bale, Michael Caine, Anne Hathaway

The house has been used by film-makers since the 1950s. TV and film production companies have traditionally favoured the west side of London because in the very early days there was less air pollution than on the east side.

This film completed Christopher Nolan's Batman trilogy. In the first film, *Batman Begins*, Wayne Manor has burnt down and Bruce Wayne (aka Batman) needs a new home; he finally gets round to finding one in the third. He is a man of good taste hence the choice of Osterley Park for the interiors of the new Wayne Manor. Exteriors were shot at local authority-owned Wollaton Hall in Nottinghamshire.

In *The Dark Knight Rises*, Wayne has moved in but not yet unpacked. So the Long Gallery had its pictures removed or wrapped and the room was littered with boxes etc. The wrapped paintings were rehung to complete the illusion. All of the gilt mirrors in the Gallery had to be removed. It also appeared that its green walls were now white but in fact the Long Gallery walls were clad with painted boards, carefully slotted onto sections of wall, to create the illusion that re-painting had taken place.

On the staircase Wayne's butler Alfred Pennyworth delivers his emotional speech threatening to quit. (The authors were accidentally trapped for an hour at the end of the corridor during this scene before sheepishly making their escape on the word 'cut'.) The Entrance Hall was used for a scene in which Anne Hathaway arrives disguised as a maid. She is of course Catwoman and later in the film she escapes – despite six-inch heels – from the Long Gallery, via a (false) window. Osterley's Library also has a classic secret door built into a bookcase, which became the entrance to the 'bat cave', although given the cave's exit was in Wales (see the **Henrhyd Falls** entry), via a film set in Los Angeles, its use would have entailed a long walk.

Nolan's Batman films were noted for being of a darker tone than any previous interpretation and are a million miles from the camp TV series of the 1960s and the Gothic versions of Tim Burton. As *The Dark Knight Rises* took over $1 billion at the box office, it's not surprising that Hollywood keeps returning to the Batman story.

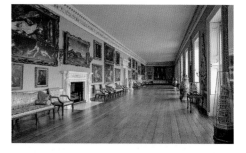

TOP Michael Caine as Alfred Pennyworth and Christian Bale as Bruce Wayne in the Entrance Hall.

ABOVE Before and after: the Long Gallery's usual look and propped and ready to shoot.

Burke and Hare (2010) 🎥

Directed by John Landis; starring Simon Pegg, Andy Serkis, Tim Curry

'Will all great Neptune's ocean wash this blood clean from my hand?' asks Macbeth. The National Trust too knows about the staining quality of blood on clothes, furniture and walls. So, when Burke and Hare wanted to get gory, they had to have bizarre practical discussions. How much blood, where is it coming from, how will it be pumped, which direction will it squirt?

When actors are shot, a small squib of fake blood is hidden under their clothes; the sound of the gun sets off a charge which rips the cloth and sprays out small amounts of blood – most of which ends up on the actor. However, a scene in the Servants Hall at Osterley involved a surgical operation with blood squirting out of the unfortunate victim. Under these circumstances, blood can easily atomise into a fine spray and spread like a vampire's air freshener. On the other hand, it has to be thick enough to be visible on camera. So, the floors were covered and the walls protected by polythene; during takes, a member of staff stood off camera holding up a plastic sheet. Luckily, being the Servants Hall, there was no fine art or exquisite furniture to be moved. However, it is cramped and once lit and filled with crew and with supporting artists standing on benches to create the impression of a surgical lecture, it quickly became hot and uncomfortable. As Dr Monro (Tim Curry) cut into the patient's leg, the pump was over-pressurised and sprayed blood all over the supporting artists – so it was just as well that precautions had been taken to protect the floor and walls.

Artificial blood is as sticky as the real stuff and so care had to be taken that it was not trodden in and then spread throughout the house. The crew cleaned themselves up and headed on to **Knole.**

BELOW Burke (Simon Pegg) and Hare (Andy Serkis) in shock as the café runs out of scones.

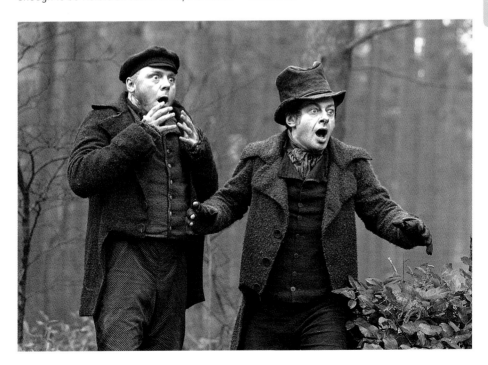

Miss Potter (2006) 🎥

Directed by Chris Noonan; starring Renée Zellweger, Ewan McGregor, Emily Watson

As well as filming at **Yew Tree Farm** in the Lake District, the production headed to Osterley for three London-based scenes. One was filmed in the Entrance Hall which became a tea room; an art gallery scene was shot in the Long Gallery.

　　The Osterley grounds stood in for Hyde Park when they shot what's known as 'drive-by' footage with a horse and carriage. They filmed the horse and carriage with the crew aboard a low-loader tracking vehicle.

Also filmed at Osterley Park and House: *An Alligator Named Daisy* (1955), *The Grass is Greener* (1960), *Mrs Brown* (1997), *The Queen* (2006), *Cranford* (TV, 2007 & 2009), *The Duchess* (2008), *Little Dorrit* (TV, 2008), *The Young Victoria* (2009), *Great Expectations* (TV, 2011), *Belle* (2013), *Doctor Thorne* (TV, 2016), *The Crown* (TV, 2016–), *Vanity Fair* (TV, 2018), *The Secret Garden* (2020), *Rebecca* (2020), *Persuasion* (2022)

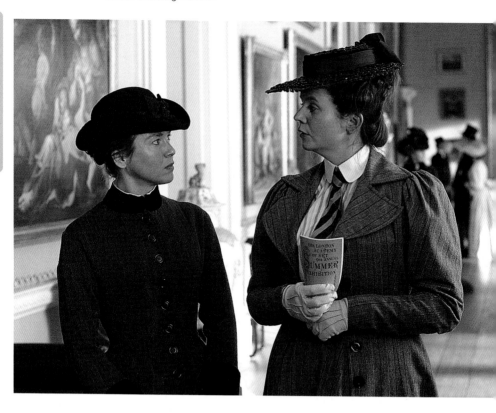

ABOVE Beatrix Potter (Renée Zellweger) and Millie Warne (Emily Watson) in the Long Gallery which stood in as an art gallery.

HAM HOUSE AND GARDEN
HAM STREET, HAM, RICHMOND, TW10 7RS

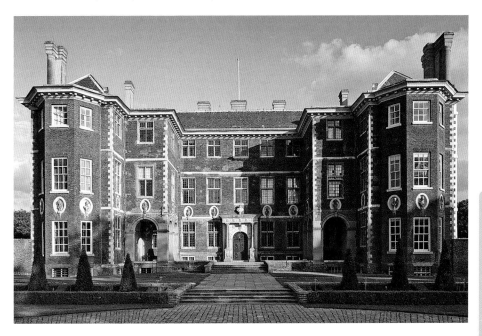

A seventeenth-century treasure house, Ham sits on the banks of the Thames in a leafy and quiet part of south-west London. Its proximity to the major film studios at Pinewood, Ealing and Shepperton, coupled with its scale and grandeur make it both a small and big screen favourite.

Never Let Me Go (2010) 🎥
Directed by Mark Romanek; starring Carey Mulligan, Keira Knightley, Andrew Garfield

In summer 2009 Ham House and Garden was, frankly, a bit of a mess because of its role in the dystopian thriller *Never Let Me Go*. Ham House had become the sinister boarding school Hailsham, where Keira Knightley, Carey Mulligan and (a pre-Spiderman) Andrew Garfield would learn their terrible, inescapable fate.

Hailsham was a neglected place and to give Ham this look the gardeners were asked not to mow the lawns or cut any hedges for nearly three weeks. At that time of year, early summer, they usually cut the lawns at least every fortnight.

With this head start, the greens department – part of the crew's art department – arrived en masse for four days' work to 'wild-up' the gardens on all sides of the house, using fake and real bits of greenery and ivy. Garden statues were also 'dirtied down' and an overgrown fountain, 5 metres (16 feet) in diameter, was added to the aptly named Fountain Garden. Signs were put up to explain the disarray to visitors and the film's location manager was on hand to give talks to provide further insight.

The square sections of lawn at the back of Ham House became a 'school football field' so the paths in between were filled in with huge amounts of turf. The meadow at the front of the house, just in front of the Thames, was the

school's rounders field. Again, the grass was the wrong length; this time it was too long and had to be cut.

A mix of both Ham House and Chiswick Town Hall (not National Trust) were used for the school's interiors. At Ham, the Great Hall, the Duchess's Bathroom and the wood-panelled Tollemache rooms were featured. Not all rooms in the house are available for filming as some are just too fragile, either due to their inlaid floors or because delicate silk and wool fibres in the tapestries can start to break down after prolonged exposure to heat and light. Three paintings were taken down in the Great Hall and replaced by suitable prop ones. While they were down the house staff took the opportunity to have them cleaned by specialist conservators. Again, a sign went up to explain why the usual paintings weren't there.

The filming went on for a week followed by two 'strike' days during which the crew remove all their props and, in this case, bits of hedge, turf and an entire fountain! As soon as they could, the Ham House garden team were out with the mowers and strimmers.

ABOVE Carey Mulligan as Kathy, Keira Knightley as Ruth and Andrew Garfield as Tommy.

ABOVE RIGHT Close up of the 'wilding'.

RIGHT Filling in the back lawn.

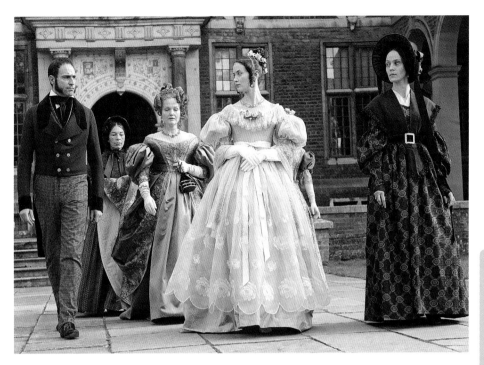

The Young Victoria (2009) 📺◄

Directed by Jean-Marc Vallée; starring Emily Blunt, Rupert Friend, Miranda Richardson, Mark Strong

ABOVE Queen Victoria (Emily Blunt), the Duchess of Kent (Miranda Richardson) and Sir John Conroy (Mark Strong) outside the front of Ham House.

The previous year Ham House looked its usual smart self when it played Kensington Palace in *The Young Victoria*. Chosen for its similarity to the real thing and with the added bonus of being in London, both the interiors and exteriors were utilised over a four-day shoot.

The film's opening sequence was shot here; Victoria is seen using the Great Hall's black and white floor for hopscotch and walking around the clipped hedges of the geometric Cherry Garden. The carved Great Staircase features when the narration describes the 'Kensington System', a plan put in place to keep the future monarch safe. For example, Victoria wasn't allowed to walk down stairs without holding her governess's hand – Victorian health and safety gone mad. Other non-National Trust houses were used for parts of Kensington Palace so Victoria is often walking between different houses as she walks between rooms. Horses and carriages were on site for two days, causing passers-by to wonder if they'd stumbled into the wrong century. **Osterley Park and House**'s Long Gallery and Eating Room also make fleeting appearances as rooms in Buckingham Palace.

Also filmed at Ham House and Garden: *Spice World* (1997), *Ballet Shoes* (TV, 2007), *Sense and Sensibility* (TV, 2008), *Downton Abbey* (TV, 2010–2015), *John Carter* (2012), *Anna Karenina* (2012), *A Little Chaos* (2014), *Taboo* (TV, 2017), *Victoria and Abdul* (2017), *Bodyguard* (TV, 2018), *Lyrebird* (2019), *Downton Abbey* (2019), *Belgravia* (TV, 2020–), *Rebecca* (2020), *The Great* (TV, 2020–), *Red, White and Royal Blue* (2023)

WIMPOLE ESTATE
ARRINGTON, ROYSTON, CAMBRIDGESHIRE, SG8 0BW

Wimpole Hall is a large country house with wonderful Georgian interiors including a rare plunge bath. The house, begun in 1640, is surrounded by 1,200 hectares (2,965 acres) of parkland including a working farm specialising in rare breeds. There are beautiful pleasure grounds, a walled garden and a folly.

Easy Virtue (2008) 🎥
Directed by Stephan Elliott; starring Jessica Biel, Ben Barnes, Colin Firth, Kristin Scott Thomas

A large imposing estate is exactly what the director ordered for *Easy Virtue*. Based on one of Noël Coward's earlier and less-well-known plays, this is a British-made romantic comedy set in the thirties. The storyline is about a glamorous American widow, Larita, who

marries a young Englishman, John Whittaker, on holiday. On their return to England, his mother, played by Kristin Scott Thomas in fine icy-snob form, takes a dislike to her daughter-in-law. His father, however, takes a shine to her.

One of the key cultural-clash scenes takes place during a fox hunt on the estate. Filming a hunt involves a tracking vehicle, a small 4x4 adapted to accommodate a camera team which, in this instance, had to drive alongside the horses to capture their headlong gallop. Added to this was Jessica Biel (Larita) joining the hunt on a motorbike – an event which also had to be tracked. To do this safely, a clear path had to be made for the vehicles as well as the horses. Luckily the Estate has enough space. Grass was cut, mole hills and stones removed, cattle grids covered. Although the scenes were outside it was still necessary to remove all signs of modernity: visitor signage, tree guards used to protect them from deer,

fences around the duck pond and rabbit hutches, all had to be removed.

The shoot involved about 30 horses and a pack of hounds thundering along, with actors hanging on, followed by a motorbike in hot pursuit. As with any other scene, the hunt was shot from different angles more than once in order to give the director enough footage to edit to make the scene visually interesting. It was also shot several times using cameras at different distances. This was not only to capture vistas and scale but also of course to film without the tracking vehicles. The hunting scene had a 1930s-style arrangement of the song 'Sex Bomb' as its soundtrack.

Dogs, like actors, don't like hanging around inactive and one of them decided to relieve itself into the cameraman's kit bag. The social media scandal ended the dog's film career.

There was also a romantic scene in the Gothic Tower when the couple are caught in the act. The Tower was due to be restored and in a fragile condition so safety checks had to be made and crew numbers limited. The set was kept by Wimpole Estate for future use as a Santa's grotto.

BOTTOM Larita and John Whittaker (Jessica Biel and Ben Barnes) in front of the Gothic Tower.

BELOW A mother-in-law not to the messed with. Kristin Scott Thomas as Veronica Whittaker.

LAVENHAM GUILDHALL

MARKET PLACE, LAVENHAM, SUDBURY, SUFFOLK, CO10 9QZ

The Guildhall is part of a small complex of sixteenth-century buildings owned by the National Trust in Lavenham – once one of England's wealthiest towns due to its involvement in the cloth trade. Originally a meeting place for the Guild of Corpus Christi, the building has since had many uses including as a meeting place, prison, workhouse and chapel.

Harry Potter and the Deathly Hallows: Part 1 (2010) 🎥

Directed by David Yates; starring Daniel Radcliffe, Emma Watson, Rupert Grint

In the seventh and penultimate Harry Potter film Harry, Hermione and Ron are on a mission to destroy Voldemort's horcruxes. The last book was split into two films and filmed back to back over 16 months with the crew moving between a huge number of locations in England, Wales and even Germany. A number of National Trust sites appear in the film: **Hardwick Hall** plays Malfoy Manor, the **Ashridge Estate** was used for 'plate shots', **Freshwater West** beach is the setting for Dobby's Shell Cottage and Lavenham Guildhall features as part of Godric's Hollow.

The fifth location is an area of limestone pavement above Malham Cove in Yorkshire. Harry and Hermione are here when they decide they need to go to Godric's Hollow to look for the Sword of Gryffindor. It's night-time, snowy and Christmas Eve when they arrive and as they walk through the village the Guildhall can be spotted behind them. They then head to the churchyard to find Harry's parents' graves. Another National Trust place has previously played Godric's Hollow when a house in **Lacock Village** was chosen as Harry's parents' house in *Harry Potter and the Philosopher's Stone*.

The shoot here at Lavenham was very brief, with a small crew of ten taking what are known as 'plate shots', stills-only photography, over just one day. These shots were then amalgamated with filming done in the studio and with visual effects work, which altogether made up the village of Godric's Hollow seen in the film.

A 'plate shot' refers to a technique that has changed completely since the term was invented. Rather like the way we still say 'booking a cab' when it is unlikely to be a horse and carriage that will turn up. Originally a plate shot was when a scenic artist would paint a backdrop onto a glass plate. The plate would be put in front of the camera and something moving was shot in the foreground to take the viewer's eye away from the fact that, for instance, the clouds weren't moving and no birds were flying. The same technique could be used to add vertiginous cliffs, lift shafts, large statues etc. Now of course it simply means taking lots of images of buildings or landscape and placing them into a computer to be manipulated. Nowadays actors can be added, buildings rearranged, or dinosaurs dropped in.

 John Lennon and Yoko Ono were in Lavenham in 1969 making a short film called *Apotheosis*. Naturally they brought a hot air balloon with them. For other National Trust Beatles connections see the entries for **Knole** and **Cliveden**.

ABOVE **Harry and Hermione find Harry's parents' grave.**

FELBRIGG HALL, GARDENS AND ESTATE
FELBRIGG, NORWICH, NORFOLK, NR11 8PR

Felbrigg is a unique and elegant country house that mixes both opulence and homeliness. The house adjoins a landscaped park with a lake and 210 hectares (519 acres) of woodland.

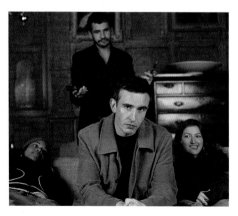

ABOVE Cast from the modern-day scenes inside Felbrigg Hall.

A Cock and Bull Story (2006) 🎥
Directed by Michael Winterbottom; starring Steve Coogan, Rob Brydon, Gillian Anderson

How do you film an eighteenth-century novel widely considered to be un-filmable? Laurence Sterne's novel *Tristram Shandy* is a rambling 'shaggy dog story' which barely gets to any point. The director Michael Winterbottom decided that the best way would be to make a film about a film company trying to make a film of *Tristram Shandy*. He also used a star-studded cast including Steve Coogan, Rob Brydon (look out for early signs of their series *The Trip*), Gillian Anderson and Stephen Fry. Brydon plays Captain Toby Shandy, injured at the Battle of Namur, who spends his retirement turning his garden into a miniature battlefield complete with cannons in order to re-create various conflicts.

Those scenes and others were shot at Felbrigg Hall and required the Trust staff to dig out the garden and the crew to fill it with

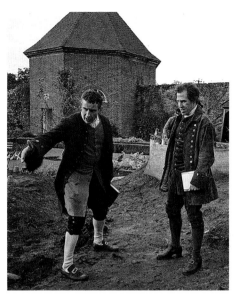

model forts plus toy soldiers and cannons. Pretty much the whole of Felbrigg was used. Although the director likes to use natural light, a lot of candles were used – lighting that may not have illuminated Felbrigg on such a scale for a century. It was a very relaxed shoot, with the public able to watch at times, and many of the cast expressed their fondness for Felbrigg. A few years later Stephen Fry would provide the voice for a high-tech 'speaking' bench at the Hall to '. . . provide comfort, balm and solace for many a weary bottom'. Sadly the bench is no longer with us.

Michael Winterbottom called it 'one of our favourite ever locations'. Such was their affection that the cast returned to Felbrigg in 2006 for a special outdoor screening in the Walled Garden to mark the 26th Cambridge Film Festival.

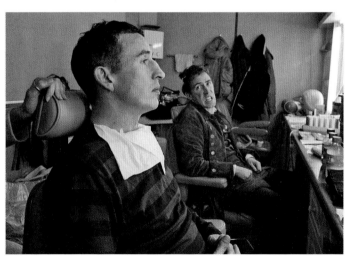

ABOVE Steve Coogan as Tristram Shandy and Rob Brydon as Captain Toby Shandy in the miniature battlefield.

LEFT Steve Coogan and Rob Brydon playing themselves in the make-up chairs.

Steve Coogan had a previous connection with the National Trust when he starred in TV comedy *I'm Alan Partridge* in 2002. **Blickling Hall**, also in Norfolk, makes an appearance in the episode 'I Know What Alan Did Last Summer' in series two. The house plays itself as Alan tries to pass it off as Bono's, claiming that visitors' cars are part of Bono's collection of hatchbacks. The Long Gallery at **Osterley Park and House** was also used in the same episode, made to appear as if it's another room at Blickling Hall.

PACKWOOD HOUSE

PACKWOOD LANE, LAPWORTH, WARWICKSHIRE, B94 6AT

This sixteenth-century manor house was bought by an industrialist in 1904 and his son Graham Baron Ash then set about restoring and transforming it into his idea of the perfect Elizabethan manor house. The famous lines of clipped yew hedges were laid out to represent the Sermon on the Mount.

The Hollow Crown (Series 1, 2012) 📺

Directed by various; starring Ben Whishaw, Clémence Poésy, Rory Kinnear, David Morrissey, Patrick Stewart

'Richard II' was the first episode in *The Hollow Crown*, a seven-part series of Shakespeare's history plays that transmitted in 2012 and 2016. The series was part of the 2012 Cultural Olympiad, a programme of cultural events that accompanied the London Olympic and Paralympic Games. The cast was stellar, the opening scene alone featuring Patrick

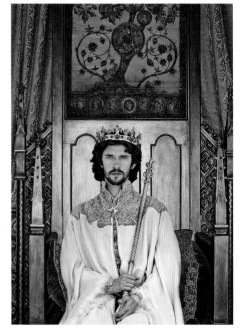

ABOVE Ben Whishaw as Richard II.

Shakespeare reportedly did visit a National Trust property nearby; legend has it that he was caught poaching deer at Charlecote Park. His membership was revoked.

Stewart, David Suchet, Rory Kinnear and David Morrissey. Ben Whishaw plays the title role and gives an electrifying and BAFTA-winning performance as a king struggling to control his nobles. Fittingly, the production chose to film some scenes at Packwood House, in the Bard's home county of Warwickshire.

A glimpse of Packwood's interior is seen right at the start of the episode when the Queen, played by Harry Potter's Clémence Poésy, and her lady-in-waiting walk down the Long Gallery.

More ground-floor rooms including the Inner Hall, Study, Drawing Room and Screens Passage can be glimpsed when a frantic scene plays out between the Duke and Duchess of York (David Suchet and Lindsay Duncan).

The clipped yew hedges in the garden provide the ideal hiding place in a scene where the Queen is listening into a conversation the gardeners are having about the King's imminent loss of power. The raised section of the 'Sermon on the Mount' is where the Queen talks things over with her lady-in-waiting.

A visitor in the 1930s said that Packwood was '. . . a house to dream of, a garden to dream in'. For the BBC, it was the perfect place to film some Shakespeare.

BELOW The Long Gallery.

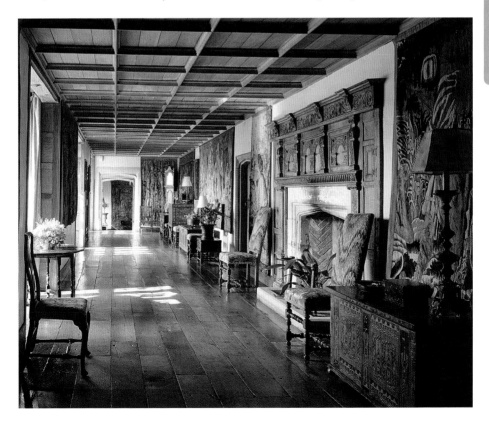

BENTHALL HALL

BROSELEY, SHROPSHIRE, TF12 5RX

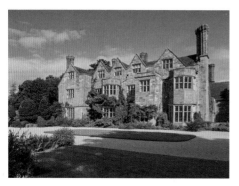

Benthall is a sixteenth-century manor house that the Benthall family called home for 500 years. The estate boasts a church built just after the Civil War and a garden planted in the nineteenth century by botanist George Maw, who was more famous for the tile factory he founded in nearby Ironbridge.

Enola Holmes (2020) 🎥
Directed by Harry Bradbeer; starring Millie Bobby Brown, Sam Claflin, Henry Cavill

There is no mention in the Sherlock Holmes novels of him having a sister, but then he didn't exist either, so author Nancy Springer invented one for a series of books aimed at young adults. Naturally, Enola is as intelligent and observant as Holmes, whilst suffering with being a woman in the Victorian era.

The film adaptation, shot in 2019, starred Millie Bobby Brown, fresh from mega hit *Stranger Things*, Henry Cavill was Sherlock and Sam Claflin played Mycroft. Benthall stood in for fictional Ferndell Hall, the Holmes family home, which was somewhat neglected by the ever-busy family, whereas Benthall most certainly isn't. A shabby fountain was added, fake weeds abounded, grass was left uncut and creeping vines were added. Production designer Michael Carlin was grateful, stating 'the gardeners and people taking care of the house at Benthall were brilliant in allowing the gardens to get really overgrown and letting us drape vines over the exterior.'

The plot involves hidden codes, safe houses, explosions, radical suffragettes and a viscount hidden in a travel bag. The shoot itself involved a carriage and a bike plus a search party gathering, after which they became the first crew at the **Ashridge Estate** to build a tree house.

Instead of a planned cinema release, the film premiered on Netflix due to the pandemic. It is reported to have been watched in 76 million households, which led to a sequel that sadly didn't need Benthall.

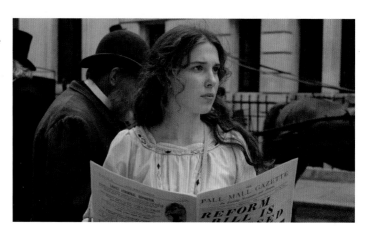

RIGHT Millie Bobby Brown as Enola Holmes.

BELTON HOUSE

GRANTHAM, LINCOLNSHIRE, NG32 2LS

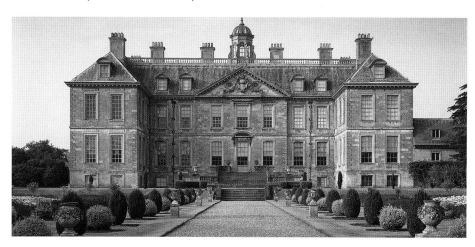

Built by influential Lincolnshire landowners, the Brownlow family, in the seventeenth century, Belton is often cited as being the perfect example of an English country house estate. It is modest in scale but has formal gardens and a deer park.

Pride and Prejudice (1995) 📺
Directed by Simon Langton; starring Jennifer Ehle, Colin Firth, Alison Steadman, Benjamin Whitrow

In 1995 Belton House was chosen for the most famous dramatisation of *Pride and Prejudice* ever made – namely the BBC's production with Colin Firth and Jennifer Ehle. The house and gardens played Rosings, home to Lady Catherine de Bourgh, and belonging to the parish of Mr Collins. Happily, the local village at Belton has a parish church allowing two locations to be filmed close to each other. The key scene shot at Belton House is of Mr Darcy returning to Rosings having been rejected by

Elizabeth Bennet. The Marble Hall features as well as the bedrooms and the grounds. Other scenes were shot at **Lyme** (you know the one), **Lacock Village** and **Lacock Abbey**.

Belton was used again for the 2006 TV production of *Jane Eyre*, in which Jane is played by Ruth Wilson. Toby Stephens plays Edward Rochester and Belton House becomes the home of Mrs Reed, the scene of Jane's traumatic childhood.

Jane Eyre was also shot at Dovedale and at Ilam, both National Trust-owned locations in Derbyshire.

RIGHT Mr Darcy (Colin Firth) and Colonel Fitzwilliam (Anthony Calf) on the steps at Belton House.

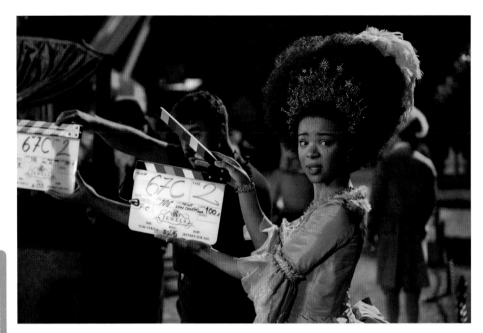

Queen Charlotte: A Bridgerton Story (2023) 📺
Directed by Tom Verica; starring India Amarteifio, Corey Mylchreest, Golda Rosheuvel, Arsema Thomas

ABOVE Queen Charlotte (India Amarteifio) wonders why she's left with the clapper board during a night shoot at Belton.

Nearly 30 years after *Pride and Prejudice*, Belton hit the costume drama big leagues once again when it was the only National Trust site chosen for the *Bridgerton* prequel. The six-part mini-series tells the story of the young Queen Charlotte and the early days of her marriage to George III. Just as lavish as *Bridgerton*, and again with a cast and crew of thousands (well, nearly), it was a huge project for Belton spanning six weeks and utilising vast swathes of the house and garden.

Belton mainly stood in as Kew Palace, George's quiet bolthole away from the court at Buckingham House. The exterior is easily recognisable when carriages arrive and depart. Rooms used inside, including The Saloon, Marble Hall, Staircase Hall and Tapestry Room, were heavily dressed or hidden with props and flattage (painted scenery), so aren't as easy to spot. Basement areas, including the Kitchen, can be seen

during George's treatments. Tony Hood, Supervising Location Manager, explains: 'We shot those scenes in the bowels of Belton. There's a long corridor underneath, and we had the experimentation rooms, the ice bath, and all sorts of weirdness down there at the bottom.'

After a few quiet years on the toad front (see page 33) our little amphibian friends made a comeback. They like to hang out in the basement corridor so, following advice from the Trust's in-house Nature Conservation Advisor, property staff had to check the area each day and move any stray toads to a safe place outside next to a pond amongst long grass. The tiny nets were back in action.

A real vegetable patch was created in the garden, made up of onions, cabbage, tomatoes, corn, carrots, kale, sweetcorn, lettuce and potatoes. It required a whopping 80 tonnes of soil. Vegetables were then

changed during the filming period to represent different seasons. The Orangery appeared as the one at Buckingham House in both the 1761 and 1817 scenes and more than a dash of film magic was used for the exterior of the Observatory (supposedly on the Kew front lawn), which was created entirely using visual effects in post-production.

RIGHT Queen Charlotte, her right-hand man Brimsley (Sam Clemmett) and an orange in the Orangery.

LEFT Lady Danbury (Adjoa Andoh), Dowager Viscountess Bridgerton (Ruth Gemmell) and Queen Charlotte (Golda Rosheuvel) take tea and a National Trust scone in Belton's Orangery.

LEFT Queen Charlotte takes a walk in the vegetable garden.

HARDWICK
DOE LEA, CHESTERFIELD, DERBYSHIRE, S44 5QJ

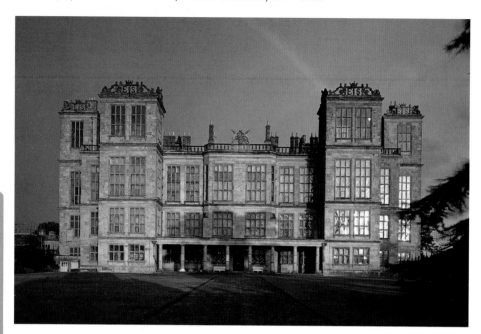

Hardwick Hall, sat on a hill within ancient parkland, is the late sixteenth-century mansion home of Elizabeth, Countess of Shrewsbury. Better known as Bess of Hardwick, she was one of the most powerful and wealthy women in Elizabethan England and set about building this hugely impressive house adorned with her own initials.

Harry Potter and the Deathly Hallows: Part 1 (2010) 🎥
Directed by David Yates; starring Daniel Radcliffe, Emma Watson, Rupert Grint, Alan Rickman

Famously Hardwick Hall has a lot of windows which was a rare and costly feature at the time, glass being the bling of the day. In the right light the windows can give a sinister feel to the Hall, making it ideal for Malfoy Towers, the

hidey-hole of evil Voldemort during the second war of the wizards. In the book, the building is described as nestling in the middle of a wood and standing in the firing line of the final battles of the war. However, the interiors of Hardwick are too delicate to risk scenes of death and destruction, not least because it is home to sixteenth-century tapestries and the daylight allowed to shine into the building is strictly rationed. Most of the original furniture and fittings are still there, reflecting Bess's opulent taste.

So, a helicopter was used to capture exterior images of Hardwick; a model was then made in the studio which was embellished with towers and spikes, before being entered into a computer for final 'building'. After which it was a case of 'let battle commence'.

For more on *Harry Potter and the Deathly Hallows: Part 1*, see the entries for **Lavenham Guildhall**, **Ashridge Estate** and **Freshwater West and Gupton Farm**.

Mary Queen of Scots (2019)

Directed by Josie Rourke; starring Saoirse Ronan, Margot Robbie, Guy Pearce, Adrian Lester

Given a plot about Queen Elizabeth I (Margot Robbie) and her cousin Mary (Saoirse Ronan), it was inevitable that the film-makers would be attracted to Hardwick Hall, being one of the finest Elizabethan buildings in the country. The house stands in for Hampton Court Palace. Mary's claims to the English throne, her difficult marriage and her struggle to hold on to power in the face of religious conflict, political intrigue and betrayal, are all explored.

Bess of Hardwick appears in the film played by Gemma Chan, but her actual status and influence during the Elizabethan period is ignored and she comes across as just a lady-in-waiting. In reality she was a rich woman by virtue of four advantageous

marriages and proved herself a loyal and trusted servant of Elizabeth when it came to dealing with the problem of Mary. It is amazing that Hollywood has not covered her story.

In this, as in many historic films, the complex story is stripped down and the plot rests on the two central characters. And for dramatic effect Elizabeth and Mary meet – which in reality they never did.

Hardwick Hall looks grand and beautiful, especially in aerial drone shots, in contrast to its portrayal in the Harry Potter film. Actors were filmed standing on its roof and the grounds were used for a hunting scene but it was reduced to a 'blink and you will miss it' moment. Appropriately enough, given the film's title, the crew spent a month shooting in Scotland.

BELOW **Margot Robbie as Elizabeth I and Guy Pearce as William Cecil on the roof at Hardwick Hall.**

<div style="text-align:right">DERBYSHIRE</div>

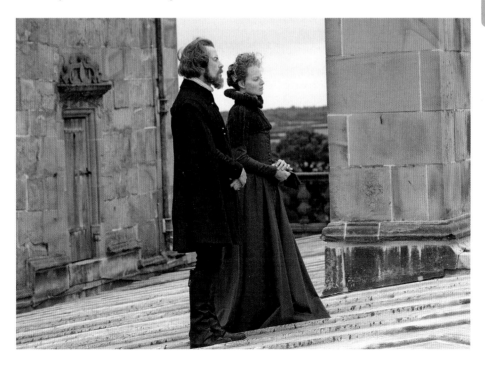

KEDLESTON HALL

NEAR QUARNDON, DERBY, DERBYSHIRE, DE22 5JH

Kedleston Hall is a Robert Adam masterpiece. Designed for entertaining, the neo-classical mansion has been the home of the Curzon family since the twelfth century. Its Eastern Museum houses a collection amassed by Lord Curzon during his tenure as Viceroy of India.

The Duchess (2008) 🎬

Directed by Saul Dibb; starring Keira Knightley, Ralph Fiennes, Charlotte Rampling

The film is a biography of the late eighteenth-century English aristocrat Georgiana Cavendish, Duchess of Devonshire, played by Keira Knightley. The story is based on the best-selling book of the same name by Amanda Foreman and details her unhappy marriage to the cruel and hypocritical Duke and her subsequent, scandalous affair with Charles Grey.

Kedleston was built in exactly the correct period for the film. The creative team of *The Duchess* was also impressed by the grandness of the property and its adaptability. The house was used for the exterior of the Spencer family's house, Althorp, and for the interiors of Devonshire House in London and of a rented villa in Bath.

The Marble Hall was Devonshire House for a dinner party and a dance where Georgiana's wig catches fire. Preparing for this incident involved the National Trust being sent a series of videos of burning wigs so that the safest approach – both for Keira and the building – could be worked out. Meanwhile two days were spent covering the delicate marble floor with its exact replica, made of flame-retardant wood. Over 150 candles were used on specially-commissioned candelabra, and stunt people dressed as 'guests' were in place to catch any falling candles. The wine used to douse the flames was in fact grape juice.

The Library at Kedleston played Althorp in

several scenes including one where the Duke (Ralph Fiennes) talks about marriage with Georgiana's mother (Charlotte Rampling). Most of the furniture was removed including a desk that had to be taken apart piece-by-piece by a Trust furniture conservator. The Saloon and State Apartment were cleared for a scene set in Bath where the Duchess's mother and the Duke visit her, demanding the end of her affair. The rooms were dressed in floral arrangements by expert florists which meant the National Trust had to be on the lookout for damaging pollen stains on furniture. The house smelt beautiful for days.

Outside, the opening picnic scene was shot on the lawn which was left unmown, the Georgians not being big on stripes. Historically accurate cakes were made especially for the filming.

Greenery was added to hide the all-too-modern children's playground and sheep were drafted in from nearby fields. The Robert Adam Bridge doubled for Bath with supporting artists in punts; they didn't move much though as the river is too shallow.

As Amanda Foreman herself said, 'no other great house of England feels so alone with the presence of history as Kedleston. This is why it was perfect for the Duchess.'

Also filmed at Kedleston Hall: *The Legend of Tarzan* (2016)

DERBYSHIRE

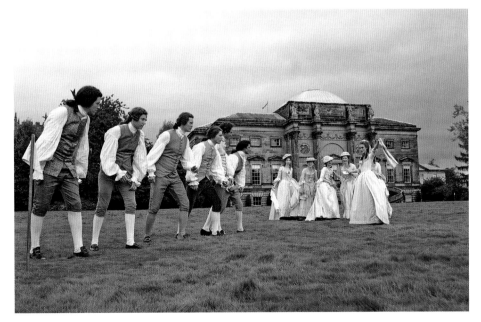

LYME

DISLEY, STOCKPORT, CHESHIRE, SK12 2NX

Lyme Park began life as a medieval hunting lodge, became an Elizabethan home and, while retaining some of its early features, was later transformed into an Italianate country house by architect Giacomo Leoni in the 1720s. Nestled on the edge of the Peak District, the house is the largest in Cheshire and is set within 567 hectares (1,401 acres) of deer park.

Pride and Prejudice (1995) 📺
Directed by Simon Langton; starring Jennifer Ehle, Colin Firth, Alison Steadman, Benjamin Whitrow

In the series the house plays Pemberley, home of Mr Darcy, object of Lizzie Bennet's eventual admiration. Andrew Davies's sparkling screenplay was notable for taking actors and crew into real locations in the English countryside. This was an innovative approach for TV dramas at the time which previously had mainly been shot in the studio. An astonishing ten million viewers were soon hooked – and this was before Mr Darcy took a dip in the lake in episode four.

The famous swim soon became, and still is, the most iconic moment in British costume drama history. Brooding and damp, Colin Firth emerged from the lake a star. The part of Mr Darcy catapulted him into an illustrious career as actor and sex symbol, an image he would sportingly send up in the Bridget Jones movies. The shot was achieved with clever editing and a tank back at the studio as the actual lake is not deep enough to dive into safely.

The viewer gets their first glimpse of 'Pemberley' when Lizzie and her aunt and uncle arrive in a carriage. Reflected in the lake and surrounded by trees, the view they see is almost exactly the one above. Impressed by

such grandeur, Lizzie's soon re-thinking her options, especially once Mr Darcy has appeared post swim and offered her uncle some fishing.

Neither of the authors of this book were there in 1995 but 20 years later they were on hand to witness the placing of a 4-metre (13-foot) high fibreglass sculpture of Mr Darcy in the lake to advertise a new drama channel. This proved to be a popular attraction and gained nationwide coverage here and in the USA. Darcy-mania is clearly showing no signs of abating.

Other National Trust sites appear in the series: when the characters wander inside Pemberley it is Sudbury Hall you see; Rosings, Lady Catherine de Bourgh's house, is in fact **Belton House**; **Lacock Village** plays the town of Meryton and **Lacock Abbey** appears briefly as a Cambridge college.

" *Just as handsome as in his portrait though perhaps a little less formally attired.* **"**

Lizzie's aunt, Mrs Gardiner

ABOVE **Mr Darcy, pre-swim.**

LEFT **The iconic duo.**

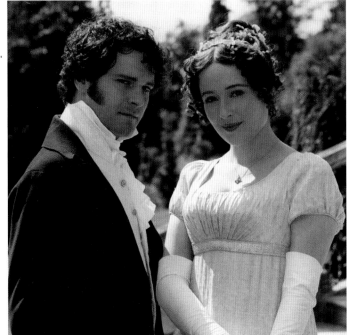

QUARRY BANK

STYAL, WILMSLOW, CHESHIRE, SK9 4HP

Samuel Greg founded a cotton mill on the River Bollin in 1784, at the turning point of the Industrial Revolution that would change the world. Today visitors can learn about the hellish working conditions of the eighteenth-century operators of spinning machines and looms; and explore the Greg family's domestic life, and the lives of the children, many as young as eight, who were forced to work 10-hour days and who lived in the cramped Apprentice House.

The Mill (2013–2014) 📺
Directed by Susan Tully, James Hawes, Bill Anderson; starring Kerrie Hayes, Andrew Lee Potts, Claire Rushbrook

It was the fascinating history of Quarry Bank that drew the attention of Channel Four and the production company as they planned to make a drama about the Industrial Revolution.

Fortunately for writer John Fay, Quarry Bank has an archive which is very detailed on the daily workings of the mill and the lives of the mill-owner's family. The plot was therefore based on actual events recorded in the archive.

It was important that the Greg family weren't judged by modern day standards and automatically made villains of the piece. The National Trust wanted a balanced approach to the story because, relative to other mill owners, the Gregs were considered enlightened, and their workers enjoyed better living conditions than those in Manchester. At the same time, it was important to recognise the vastly different living conditions experienced by, say, Samuel Greg's own children, the children of the millworkers who lived in the village, and the apprentice children who lived in the Apprentice House.

Naturally, the series was filmed at Quarry Bank, although some of the machinery had to be reconstructed in a studio as it was too dangerous for actors to be near the real thing. Otherwise, the mill was made to look as it

would have done in its heyday: littered with carts, bales, horse dung (false), urchins, workers and a carpet of (rubber) cobbles. There were several weeks of filming but throughout Quarry Bank remained open to the public. Visitors enjoyed the chance to see a TV drama being made and to experience a hint of what the mill would have felt like in the 1830s.

As in many TV history dramas, certain characters were an amalgam of real people and characters invented with artistic license. The National Trust created a website that separated truth from fiction.

The first episode was watched by 3.8 million people making it Channel 4's biggest launch in three years. By episode three, the number of people visiting Quarry Bank had increased by 60 per cent. Five thousand people a day were visiting the website to discover more about the real stories and issues covered by the series; these included slavery, Chartism, child labour and blacklisting to prevent future employment.

Also filmed at Quarry Bank: *Belgravia* (TV, 2020–)

" Watching the actors playing the apprentices walk down the road from the Apprentice House to the Mill, hearing the sounds of their clogs on the cobbles, all in a fake moonlight, on a bitterly cold evening, was incredibly moving. We don't have photographs to tell us what the Mill looked like in the early nineteenth century and so we have nothing to help us visualise it, so seeing the set, and the actors in costume, is really helpful for our work. "

Quarry Bank's general manager

CHESHIRE

YEW TREE FARM

CONISTON, CUMBRIA, LA21 8DP

Yew Tree Farm in Coniston is set at the head of a picturesque valley in the Lake District National Park. Once owned by Beatrix Potter, it is still a working farm as well as a family home and popular holiday let. The farm is not open to the public but her fans can visit nearby National Trust sites the Beatrix Potter Gallery, Hill Top and Tarn Hows, all of which have connections to the writer.

Miss Potter (2006) 🎥

Directed by Chris Noonan; starring Renée Zellweger, Ewan McGregor, Emily Watson

The National Trust was involved at the very start of this film which proved an often-delayed project. Beatrix Potter supported the Trust by donating land in the Lake District;

thus the Trust were very keen for her story to be told. Before filming began the local staff took the production team on a guided tour highlighting the most suitable locations. Sadly, this couldn't include the real Hill Top, Beatrix Potter's home, as it is too small for a feature film crew and is always busy with visitors from around the world.

Eventually attention settled on Yew Tree Farm and the farmhouse was repainted and the garden dressed to resemble the famous Peter Rabbit garden of the books. The barn was then re-populated with farmyard animals, including some pigs that every day had to be made-up with harmless paint to resemble rare breeds. This was simpler than moving farm animals around, which can be expensive and bureaucratic. Among the sheep were Herdwicks, an ancient local breed. Potter had her own flock and contributed greatly to their continuance and conservation.

The area is not swamped with hotels and it was close to Easter when filming *Miss Potter*

started so some of the crew had to stay as far away as Manchester and Carlisle. After the Lakes the production team headed to **Osterley Park and House** to shoot a tea room and an art gallery scene, and what are known as 'drive-bys' involving a horse-drawn carriage. Basically, these are shots of a carriage – in this case supposedly in Hyde Park – together with scenes inside the carriage, filmed while it is being towed along on an adapted truck.

For Renée Zellweger, the film was a passion project as she was also an executive producer; her research included reading the letters between Beatrix Potter and her publisher, Norman Warne – their love affair was the crux of the film.

❝I mean, what a fascinating life, and how could I know so little about this woman? It just drew me in and I wanted to know more. It's just such a beautiful story. So, it started with that. I liked her a lot. I liked her rich, internal life. I liked that she was so witty and quick. I loved her wry sense of humour. I just thought of her as a person I'd like to know, that's where a lot of the appeal came from – she made me smile.❞

Renée Zellweger

BELOW Renée Zellweger as Miss Potter standing outside the farm, after it had been painted and dressed by the art department.

BORROWDALE AND DERWENT WATER

NEAR KESWICK, CUMBRIA

Derwent Water is a popular lake near Keswick, surrounded by fells and the dramatic Castle Crag.

Star Wars: Episode VII – The Force Awakens (2015) 📽◀

Directed by J.J. Abrams; starring John Boyega, Daisy Ridley, Harrison Ford, Carrie Fisher

The National Trust can, and has, provided film locations that replicate the scenery and buildings of other countries, magical kingdoms and even other planets. It's a lucky old planet that looks as lovely as the Lake District. Most sci-fi films opt for places such as Jordan for a planet that is dry and hostile, and Iceland if it needs to be dramatic with a hint of danger. It was a bit of a surprise when the Star Wars franchise decided to go green. It is handily highlighted with some dialogue: 'I didn't know there was so much green in the whole galaxy.' Fancy.

Star Wars: Episode VII – The Force Awakens has a vast plot continuing the Star Wars saga and also rebooting it for a new generation.

In order to create the planet Takodana, a helicopter with a camera rig was flown over Watendlath Fell, across Derwent Water (made larger in the finished film); then it flew over Walla Crag, towards Keswick. Maz Kanata's castle was computer-generated. Rey, played by Daisy Ridley, walks onto Takodana, and Borrowdale can be seen in the background – as it can again in a battle with Stormtroopers. Thirlmere is visited by X-wing fighters during a dogfight sequence. May the force be with you!

BELOW X-wing fighters in battle.

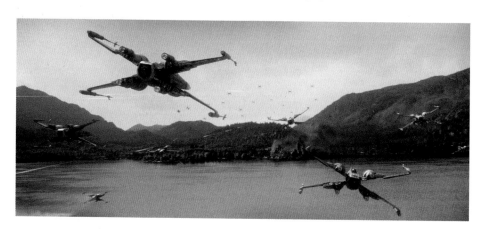

FOUNTAINS ABBEY AND STUDLEY ROYAL WATER GARDEN

NEAR RIPON, NORTH YORKSHIRE, HG4 3DY

The ruined medieval abbey adjoins Studley Royal Water Garden, a World Heritage Site. Created in the eighteenth century, the garden encompasses statues, follies and cascades as well as a deer park.

LEFT The History Boys school trip.

The History Boys (2006) 🎥

Directed by Nicholas Hytner; starring Richard Griffiths, James Corden, Dominic Cooper

Occasionally a stage production comes along that has a cast of unknowns all destined for fame and then transfers to the big screen almost immediately. *Another Country*, a play by Julian Mitchell was one such, and *The History Boys* another, starring as it did James Corden, Russell Tovey and Dominic Cooper. In *The History Boys*, a group of sixth-formers are being groomed for Oxbridge by unorthodox teacher Hector, played by Richard Griffiths.

The play and screenplay were written by national treasure Alan Bennett. The theme of the story is the value of education and how it is applied, and leads to a school field trip to Fountains Abbey towards the end of the film. Bennett clearly has affection for Fountains Abbey as it also features in an earlier work by him, made for TV. Called *A Day Out* (1972), its focus is a cycle club trip to the Abbey.

131

The Secret Garden (2020) 🎬

Directed by Marc Munden; starring Colin Firth, Julie Walters, Dixie Egerickx

Lonely orphan Mary Lennox discovers part of the secret garden at Fountains Abbey in this adaptation of Frances Hodgson Burnett's classic novel. The East Guest House was chosen to become one part of the garden at Mary's uncle's house, Misselthwaite Manor. Other scenes in the film were shot at **Bodnant Garden** in Wales. The East Guest House building is part of a small complex that was originally used to accommodate important visitors to the site. Nowadays it's a very picturesque roofless ruin.

The film's location manager, Tom Howard, explained the look the team wanted to achieve: 'The director wanted to get an element of water into the garden and we looked at lots of water gardens and gardens with fountains but nothing was quite right. We also wanted somewhere that looked very old so we started looking at monasteries. The East Guest House was ideal as it's really striking and large enough to fill with water, which would provide some lovely reflections.' It certainly fits the 'very old' brief, 800 years to be exact.

The film crew spent seven days preparing the set for what would be a one-day shoot. Modern floodlight fittings were removed by

contractors just before the shoot and put back immediately after. The building was flooded with 5 centimetres (2 inches) of water on top of a waterproof membrane and 'wild-ed' up with fake greenery to create the required overgrown look. The scale of the estate meant that filming could be done on an open day despite the crew numbering more than 80.

Also filmed at Fountains Abbey: *The Omen III: The Final Conflict* (1981), *Death Comes to Pemberley* (TV, 2013), *Gunpowder* (TV, 2017), *The Witcher* (TV, 2019–)

ABOVE Dixie Egerickx as Mary Lennox.

RIGHT The East Guest House flooded, 'wild-ed' and ready for action.

CRAGSIDE

ROTHBURY, MORPETH, NORTHUMBERLAND, NE65 7PX

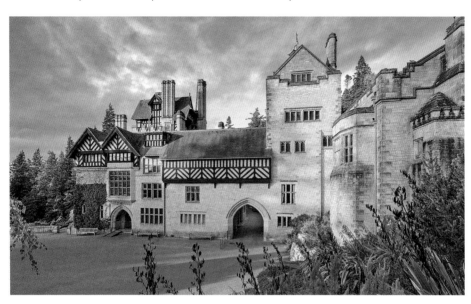

Perched dramatically on the edge of a rocky Northumberland crag, Cragside is a wonder of the Victorian age. Created by pioneering inventor and industrialist Lord William Armstrong, it was the first house in the world to be lit by hydro-electricity. An Arts and Crafts masterpiece, this innovative home can also lay claim to one of the world's largest inglenook fireplaces.

Jurassic World: Fallen Kingdom (2018) 🎥◀

Directed by J. A. Bayona; starring Bryce Dallas Howard, Chris Pratt, Rafe Spall

Jurassic World: Fallen Kingdom is the fifth film in the massively popular franchise, all directed or produced by Steven Spielberg. This instalment was, at the time of printing, the twentieth highest grossing film of all time.

LEFT Chris Pratt as Owen Grady, Justice Smith as Franklin Webb, Bryce Dallas Howard as Claire Dearing, Daniella Pineda as Zia Rodriguez and a dinosaur as himself.

Cragside appears as Lockwood Manor, the northern California home of eccentric dinosaur enthusiast Sir Benjamin Lockwood. The exterior of the 'Manor' seen in the film is based on Cragside with visual effects work later adding a tower and entrance staircase to the central section of the building.

Cragside's setting was undoubtedly one reason the film-makers were drawn to the house, surrounded as it is by tall pine trees reminiscent of those in northern California. When the house is first seen in the film, the camera pans across a vast wooded valley in which Cragside's Iron Bridge can be spotted. The stream which runs through the valley has been transformed into a road. The Drawing Room's glass ceiling features significantly when action moves to the roof but, fear not, a set version of it was built in the studio.

All of the footage needed was gathered in just two days of drone filming and stills photography, on closed days in winter. Much of the film's action takes place in the vast underground laboratories of Lockwood's house. This would have been tricky at the real Cragside as, although the kitchens contain all sorts of Victorian inventions, there definitely isn't room for dinosaurs; Pinewood Studios stepped in for that.

LEFT The added-on staircase re-created on the back lot of the studio.

LEFT The Drawing Room's glass ceiling re-created in the studio.

FRESHWATER WEST AND GUPTON FARM

CASTLEMARTIN, PEMBROKESHIRE, SA71 5HW

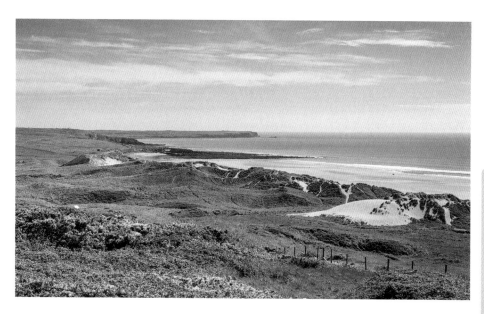

PEMBROKESHIRE

Freshwater West is popular with surfers, walkers, families and film crews. The beach is backed by sand dunes and is designated a Site of Special Scientific Interest (SSSI). At low tide it is possible to see the remains of an ancient drowned forest. The beach is home to lapwings and grey seals.

Harry Potter and the Deathly Hallows: Part 1 & Part 2 (2010 & 2011) 🎥

Both directed by David Yates; starring Daniel Radcliffe, Emma Watson, Rupert Grint

Shell Cottage is the place to which mortally wounded Dobby – the house elf (every school should have one) – escapes to see Harry and, spoiler alert, it is the beach where he dies. These two films marked the end of the Harry Potter saga and the final battle to destroy the evil Voldemort.

The Cottage took several days to build and had a distinctive roof made of massive scallop shells, and tall chimneys. So, it couldn't really be missed. The weather can be windy on that part of the coast, which is why it is a surfing hot spot, and Shell Cottage was in fact just a 'shell' as its interiors were shot in the studio. It was weighted down with plastic barrels filled with

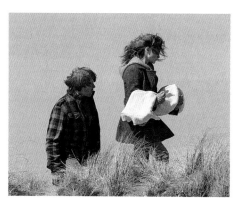

LEFT Hermione and Ron bury Dobby.

135

water. Security was also on hand 24 hours a day to prevent keen fans from taking it apart for souvenirs. The Cottage nestled on the edge of the dunes that fringe the mile-long beach. The three principal actors were on location here, causing the usual excitement among local residents and media.

Since the film's release, the beach has become a site of pilgrimage for Potter fans. The Cottage has long gone of course but many fans leave stones with Dobby's name painted on them.

For more on *Harry Potter and the Deathly Hallows: Part 1 & Part 2*, see the entries for **Lavenham Guildhall, Hardwick** and **Ashridge Estate**.

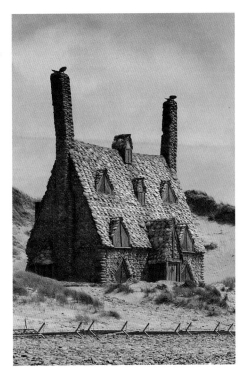

RIGHT Shell Cottage.

BELOW Filming underway on the beach.

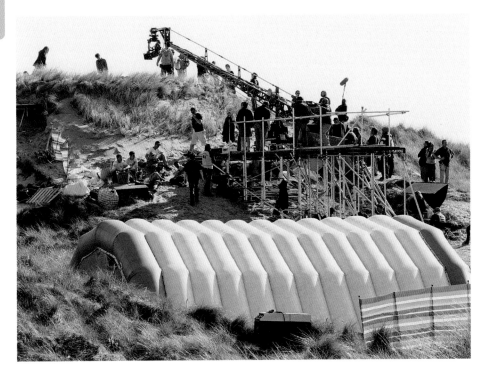

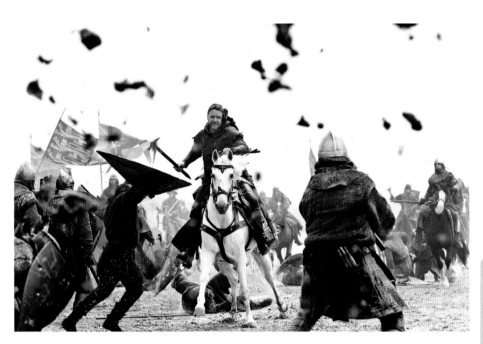

Robin Hood (2010) 🎥
Directed by Ridley Scott; starring Russell Crowe, Cate Blanchett, Mark Strong

ABOVE Russell Crowe in *Robin Hood* at Freshwater West beach.

Film crews are like London buses – either none or three at once. So just as the Trust was saying goodbye to Harry Potter on this Welsh beach, along came Robin Hood.

Ridley Scott's epic retelling of the Robin Hood legend encompassed not just the **Ashridge Estate** but also Dovedale in the Peak District and here at Freshwater West. The scene was the climactic battle against the French (who else?) at 'Dungeness'. The real Dungeness is actually in Kent, has a pebble beach and is far too narrow to accommodate the battle scene Ridley had in mind. Over six hundred supporting artists (four hundred of whom were recruited locally), and 150 horses were used during the filming on the beach. The wooden frame of a ship complete with sails was dressed onto the rocks to suggest a shipwreck; hut structures were added along with extra seaweed, boats, coracles, oyster fishermen's nets and a 9m x 4.5m (30 ft x 15 ft) tower. The latter was used to host a green screen which, using visual effects technology

to superimpose images, would later become a massive gothic castle in the finished film.

The film-makers initially used real oyster shells as set dressing, but they were non-indigenous so had to be removed. During filming, Robin Hood (Russell Crowe) stayed overnight in a Winnebago parked in the dunes; it was christened 'Russell Square'. See what they did there?

The shoot took weeks and required three separate bases, one of which was just for the horses. Large battle scenes have to be choreographed almost like a ballet to avoid the possibility of injury. Each move is planned and rehearsed over and over before being shot from various angles. The weather also needs to be consistent otherwise you have half your army fighting in the rain and the rest bathed in summer sunshine. For a battle filmed on the beach, the ebb and flow of the tide also alters the area of sand, but this mustn't show up on camera; tides also dictate the time you have to shoot.

DYFFRYN GARDENS
ST NICHOLAS, VALE OF GLAMORGAN, CF5 6SU

Dyffryn Gardens cover more than 22 hectares (54 acres) and were designed by eminent landscape architect Thomas Mawson in 1906. Mawson included a Pompeiian garden, a paved court, a reflecting pool and a Mediterranean garden as well as a large glasshouse, statuary collection and arboretum. The estate surrounds a restored Victorian mansion.

Doctor Who (Series 2, 2006; Series 4, 2008; Series 11, 2018) 📺
Directed by Euros Lyn, Jennifer Perrott; starring David Tennant, Billie Piper, Sophia Myles, Jodie Whittaker, Tosin Cole

For the time-travelling Doctor Who, Dyffryn Gardens makes the perfect portal. The show is made in nearby Cardiff and because TV budgets are limited, any location that provides a variety of spaces gets used more than once.

Dyffryn has been used four times, so far. Probably more, in other time dimensions.

In the 2006 episode 'The Girl In The Fireplace', Dyffryn stood in as the gardens of the Palace of Versailles and part of the Palace itself. The Doctor, in the form of David Tennant, was required to save Madame de Pompadour from clockwork killing-machines.

The courtyard was also used for another 2006 episode called 'Tooth and Claw', set this time in Scotland. It features 'Queen Victoria' who arrives at the Torchwood Estate only to find it filled with sinister monks and a werewolf. How annoying. Dyffryn provided the courtyard.

Doctor Who came back in 2008 for an episode called 'Forest of the Dead'. Dyffryn played a cyber hospital; Katherine Tate was a guest star and Alex Kingston was introduced as River Song. **Tyntesfield** has also been used for the series revival.

In 2018, the Doctor returned to Dyffryn but this time he had regenerated into a woman –

namely Jodie Whittaker. Being an alien, the change was no big deal, but for the press it was massive and speculation as to who was to be the next Dr Who rumbled on for months. The episode was called 'Kerblam!' and the plot involved an intergalactic online shopping service and its robotic AI (artificially intelligent) managers who kill any shirking workers in the warehouse. Dyffryn Gardens were used as a workers' picnic area with frightening-looking, impractically designed furniture and patrolled by sinister robots.

These episodes reached between six to eight million viewers and marked the clear revival of a show that had originally been killed off back in 1989. The *Doctor Who* fan base today is worldwide and fanatical and keen to know everything about how the series is made, including the locations. For a show that started in 1963 it is likely that other National Trust places have provided locations in the more distant past; the Trust is aware of two 1970s episodes, for example, shot at **Frensham Little Pond** in Surrey.

Also filmed at Dyffryn Gardens: Torchwood (TV, 2006–2011), Merlin (TV, 2008–2012), Da Vinci's Demons (TV, 2013–2015), Doctor Thorne (TV, 2016)

Before the house came to the National Trust, an episode of a Doctor Who spin-off *The Sarah Jane Adventures* was shot at Dyffryn. The film crew were given permission to re-paper one of the rooms. This has since become one of the house's most admired wallpapers!

BELOW David Tennant as the Doctor and Billie Piper as Rose Tyler.

TREDEGAR HOUSE

PENCARN WAY, NEWPORT, NP10 8YW

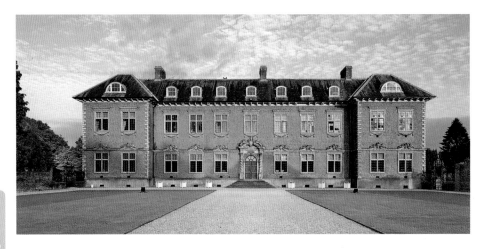

There's been a house on this site since medieval times and for more than 500 years it was home to one of the greatest Welsh families, the Morgans, later Lords Tredegar. The present house sits within 36 hectares (89 acres) of gardens and parkland and is one of the UK's most significant and dazzling late seventeenth-century houses.

 Between 2005 and 2009 a total of 11 episodes of *Doctor Who* filmed scenes at Tredegar House.

in the trenches, the plot concerns a group of officers led by the mentally disintegrating Captain Stanhope and his second-in-command, Lieutenant Osborne.

Journey's End (2018)

Directed by Saul Dibb; starring Sam Claflin, Paul Bettany, Toby Jones

For *Journey's End* the film-makers bypassed Tredegar House as their interest was in its extensive grounds, especially the stables. The aim was to create a First World War British army base in France. Rare military vehicles were drafted in along with tents, horses and 100 supporting artists, many of whom were historical re-enactors used to camping overnight. The Stable Hall was used as an army general's office.

The film was based on the play written by R. C. Sherriff, who was also a successful script writer (*Goodbye Mr Chips* and *The Dam Busters*). Based on Sherriff's own experiences

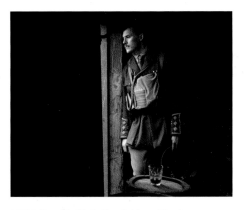

ABOVE Sam Claflin in the stables at Tredegar.

Also filmed at Tredegar House: *Being Human* (TV, 2008–2013), *Sherlock* (TV, 2010–), *Da Vinci's Demons* (TV, 2013–2015), *Industry* (TV, 2020–)

HENRHYD FALLS

NEAR COELBREN, BRECON BEACONS, POWYS, SA10 9PH

The Falls, nestled in the Brecon Beacons, are the highest in south Wales with a drop of 27 metres (89 feet). They occur at a geological fault on the river Nant Llech and are approached through a densely wooded valley.

The Dark Knight Rises (2012) 🎥

Directed by Christopher Nolan; starring Christian Bale, Michael Caine, Anne Hathaway, Joseph Gordon-Levitt

Although the entrance to the 'bat cave' was at **Osterley Park and House**, the director Christopher Nolan wanted the secret exit to be spectacular and natural. Henrhyd Falls ticks those boxes but obviously how spectacular it looks depends on the weather. The film crew couldn't risk it looking anything other than a mini Niagara Falls. It was agreed to allow them to partially dam the river for several days in order to build up a reservoir of water to unleash as the camera rolled. The National

Trust worked with the Environment Agency and the Countryside Council for Wales to manage any environmental impact. It was judged to be no different from having a wet spell in the summer, hardly un-heard of in Wales. There was also a 'test day' to see if the desired effect was achievable.

The water was held back by a rig of sandbags and a timber gate to control water flow. The crew had to walk their kit down a steep footpath and construct the camera on site. On the day a diversion was placed on the footpath.

Once they were ready and Robin (Joseph Gordon-Levitt) was in position, the command was given: further up the river, the gate was opened and a torrent of water cascaded down as if in full spate for about ten minutes. Although the waterfall was made to look as if it hid a cave entrance and exit in the film, there is in fact no cave at Henrhyd – just a hollow behind the Falls. Usually such small scenes are shot by the 'second unit' (a smaller-sized crew, without the main director) and the waterfall could anyway have been enhanced with a computer, but Christopher Nolan likes to do it 'old school'.

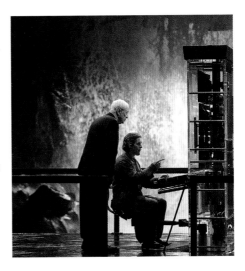

RIGHT Michael Caine and Christian Bale in the bat cave, a studio set not really behind Henrhyd Falls.

BODNANT GARDEN
TAL-Y-CAFN, NEAR COLWYN BAY, CONWY, LL28 5RE

Bodnant Garden reflects and complements the grandeur of its Snowdonia setting, nestling as it does against the backdrop of the meandering Conwy Valley. This Grade I listed garden represents a harmonious blend of historic and contemporary planting.

The Secret Garden (2020) 🎥
Directed by Marc Munden; starring Colin Firth, Julie Walters, Dixie Egerickx

The task here was to help find the most famous magical garden in children's literature. First published in 1911, Frances Hodgson Burnett's novel concerns 10-year-old Mary, orphaned in India, who returns to England and discovers the emotional healing powers of nature within a lost Yorkshire garden.

It would have been against the spirit of the book to build a garden in the back lot of a studio. So, real gardens were used and a composite created from a number of Britain's finest gardens. The film's producer, Rosie Alison, explained Bodnant's appeal: 'We were first drawn to the garden due to the glorious mountain stream that runs through The Dell, surrounded by flowers of many colours and sizes, from hostas to hydrangeas. The vibrant and otherworldly aspects of Bodnant valley made it a clear choice.'

The film-makers were also attracted by the famous Laburnum Arch at Bodnant, which is a riot of yellow and forms a striking tunnel of flowers. It doesn't bloom on cue of course, so the camera crew were on standby to come and shoot scenes as soon as it was at its peak.

After that had been captured on film, the crew returned to shoot in The Dell. Bodnant also offers a formal garden and a sweeping terraced lawn which falls away into a wooded valley complete with stream. The crew picked

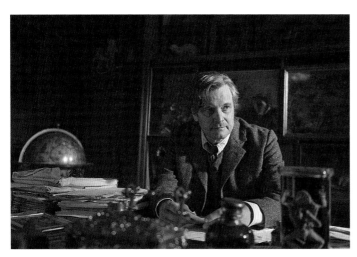

LEFT Colin Firth as Lord Archibald Craven.

BELOW The Laburnum Arch.

the correct June as the sun shone and the gardens looked magnificent. As in the book the garden seemed to mellow the crew; the shoot was relaxed, and when not working most of them lay on the grass. The biggest decision of the day seemed to be the choice of ice cream (choc ice on a stick, mainly).

For more on *The Secret Garden*, see the entry for **Fountains Abbey and Studley Royal Water Garden**.

PENRHYN CASTLE

BANGOR, GWYNEDD, LL57 4HT

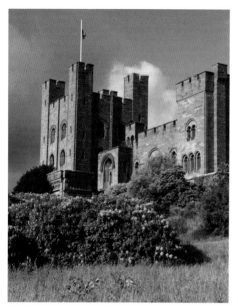

Built between 1820 and 1837, Penrhyn is a stylised fairy-tale version of a Norman castle. Thomas Hopper was the architect, hired by George Dawkins-Pennant MP. It sits in 60 acres of garden and woodland and on a clear day you can see the summit of Snowdon, the Great Orme and Puffin Island.

Watchmen (2019) 📺

Directed by various; starring Regina King, Jeremy Irons, Don Johnson

The massive success of comic book and graphic novel adaptations into films – *The Avengers, Iron Man, Spider-Man,* etc. – always meant that TV would want to get in on the act. *Watchmen* was published in the 1980s and was written by Northampton's own Alan Moore, some of whose other works have been made into films that he famously disowns.

The story is set in an alternative universe where superheroes helped America win the Vietnam War and Watergate didn't happen. However, World War III is beckoning.

Penrhyn Castle had the right alternative universe feel, especially once 30 dead bodies in a cart (some of them naked) were added. Some intimate scenes require a closed set, with only essential crew in the room, including filming conservators, especially if there is romantic candlelight or an ancient bed is involved. There was a lot of artificial blood to contend with, as well as stretched animal hides and gunfire. On top of that was a cake-smashing scene which required us to protect the floor and walls. Conservators stood off camera and dodged the debris.

As usual, there was a detailed report on the shoot outlining what went well, what didn't, who tried to sneak a coffee into the house, did the false walls soak up enough blood, were the child actors chaperoned, etc. The report for *Watchmen* contained the Filming and Location Office's favourite line of all time, namely 'the massacre in the Dining Room went well' – which was good to know.

LEFT Jeremy decides what to wear for the massacre.

GIANT'S CAUSEWAY

44 CAUSEWAY ROAD, BUSHMILLS, COUNTY ANTRIM, BT57 8SU

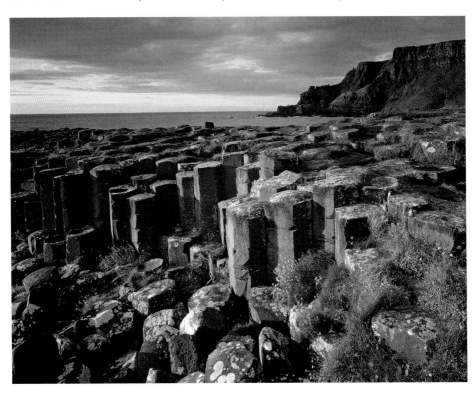

COUNTY ANTRIM

The world-famous basalt columns are flanked by the wild North Atlantic ocean. Northern Ireland's only World Heritage Site was formed sixty million years ago by volcanic eruptions.

Hellboy II: The Golden Army (2008) 🎥

Directed by Guillermo del Toro; starring Ron Perlman, Selma Blair, John Hurt

The iconic Causeway is not just an UNESCO World Heritage site but one of the busiest visitor sites the National Trust has. Therefore filming opportunities here are always limited unless you bring a scaled down crew, which was the case here. Hellboy is a demon who, in this film, is summoned by the Nazis and then rescued by the Allies. Ron Perlman plays the red-faced, slightly horned, cigar-chomping son of Satan. Written and directed by Guillermo del Toro, the production took some very early morning helicopter shots of the Causeway. Then they manipulated those shots using visual effects to make the Causeway the home of the Golden Army, locked in an ancient war between human and magical creatures.

The Causeway of course has its own legends, such as the fable of Finn McCool and his dispute with Benandonner, the Scottish giant. The story goes that the Causeway, created by Finn McCool, was destroyed by Benandonner as he ran back to Scotland so that Finn couldn't follow him. Alternatively the whole thing was made by molten basalt cooling about 60 million years ago.

The Causeway also features in *Dracula*

Untold (2014) along with Mount Stewart and Divis and the Black Mountain, both in Northern Ireland. This time the crew did actually film on the ground as well as building a Giant's Causeway-shaped cave in the studio. Luke Evans played the title role and the Northern Irish locations played a fictional region of Transylvania.

Also filmed at the Giant's Causeway: *Cold Feet* (TV, 1997–), *Your Highness* (2011)

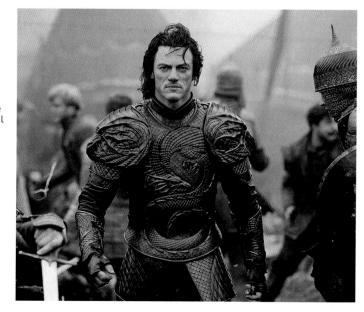

RIGHT Luke Evans as Vlad in *Dracula Untold*.

BELOW For *Hellboy II: The Golden Army*, Ron Perlman and Selma Blair were filmed on a roadside verge in Hungary. Shots of the Giant's Causeway were added later using visual effects.

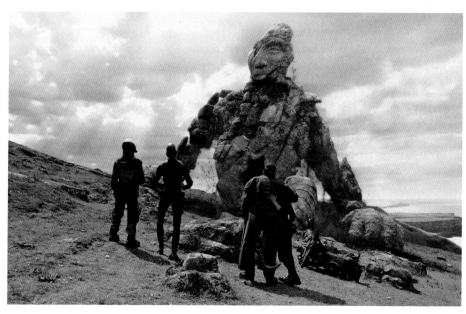

COUNTY ANTRIM

CASTLE WARD

STRANGFORD, DOWNPATRICK, COUNTY DOWN, BT30 7BA

A rare mix of both Gothic and Classical styles, eighteenth-century Castle Ward sits next to the calm waters of Strangford Lough. The Georgian farmyard with its distinctive towers was built for defensive purposes in 1610.

Game of Thrones (2011–2019) 📺
Directed by various; starring Sean Bean, Michelle Fairley, Richard Madden

Game of Thrones was one of the most watched TV shows of all time and helped usher in a new golden age for television. The fantasy drama, nothing short of a phenomenon, spanned eight award-winning series and was based on George R.R. Martin's series of fantasy novels, *A Song of Ice and Fire*. Gripping action centred on the brutal battle for the coveted Iron Throne.

The production chose the Titanic Quarter

Studios in Belfast as its base and much of the action in the fictional 'north' is filmed in the wild beauty of the Northern Irish countryside. In series one and two, Castle Ward's farmyard and towers were chosen as the backdrop for Winterfell, the ancestral seat of House Stark. For each visit, the crew spent two to three weeks preparing the site before filming began. Preparations included placing turf on the roofs, adding some smaller buildings, creating a more rustic ground covering and constructing a gate house. Doors were removed from their hinges and prop ones hung in their place. All of this meticulous work made the fantasy world incredibly real. So real in fact that, at the start of the shoot, Castle Ward's general manager was alarmed to see that the art department's fire torches were fixed to its historic walls – only to discover the wall was 'flattage', two inches thick and made of timber.

Other scenes filmed at Castle Ward included those at the Whispering Wood, Robb

Stark's Camp and the Baelor battle; it's also where Brienne confronts the Stark men.

The general manager at Castle Ward explained the incredible impact the filming made: 'When we were first approached as a location for the show, we didn't realise how big it was going to be . . . the number of visitors coming to see the real-life Winterfell peaked at 3,000 per month and we still continue to welcome around 2,000 fans every month. Whereas, before *Game of Thrones,* we were welcoming visitors from 12 countries, they are now coming from 80 countries, a sure sign of the show's global reach.'

Other National Trust sites dotted around Northern Ireland were also used for key scenes in the show. Larrybane Quarry in County Antrim, mined for chalk until the 1970s, was the setting for Renly Baratheon's camp in series two. It usually serves a rather less glamorous purpose, as the National Trust's overflow car park for the adjacent Carrick-a-Rede rope bridge. Ten or so miles down the road lies Mussenden Temple at the Downhill Demesne and Hezlett House in County Londonderry. The crew used the Temple as a 'camera position' in series two to capture

TOP Jon Snow (Kit Harington), Bran Stark (Isaac Hempstead Wright) and Robb Stark (Richard Madden) at Castle Ward's Winterfell set.

ABOVE Larrybane Quarry, aka an overflow car park.

scenes taking place below on Downhill Beach (not National Trust). With only a small team involved, camera positions were easy to achieve and the property could remain open to visitors; as the crew travelled light there was no concern about production vehicles and equipment taking up space in the car park. Downhill Beach starred as Dragonstone.

Another County Londonderry place, Portstewart Strand, hosted six days of filming. One of Northern Ireland's finest beaches, the two-mile-long stretch of sand is backed by huge sand dunes rich in wildlife. One part of the beach had to be closed off for two days as it would have been logistically impossible to host both the crew and beachgoers. Horses were used and filming was carried out from a boat. The scenes appeared in series five when Jaime Lannister and Bronn are on route to Dorne.

Murlough Bay in County Antrim, not to be confused with the Trust's Murlough National Nature Reserve in County Down, starred as the Iron Islands where Davos Seaworth was stranded after the Battle of Blackwater in series three.

Also filmed at Castle Ward: *The Woman in White* (TV. 2018). *Bloodlands* (TV. 2021–). *Dungeons and Dragons: Honour Among Thieves* (2023). Tom Jones (TV. 2023)

LEFT **Portstewart Strand.**

BELOW **Mussenden Temple.**

INDEX

PICTURE CREDITS

Alamy: 9, 13 bottom, 16 both, 23 both, 38, 39, 47, 48 both, 50, 52, 78, 109 top, 111, 135 bottom, 140 bottom, 144 bottom.

BBC Photo Library: 46, 53 bottom, 55, 89 top left, 117 bottom, 125 top, 139.

Drew Buckley: 135 top.

Courtesy of Carnival Film & Television Limited: 49, 63, 64 both, 114 bottom.

Company Pictures and Playground Entertainment for BBC2: 26 top, 28 bottom, 36.

Ecosse Films/Nick Wall: 68 bottom.

Harvey Edgington: 82 bottom.

Jemma Finch: 108.

Patsy Floyd: 32, 34 bottom.

2018 Focus Features: 146 bottom.

Getty Images: 29 bottom, 45 both, 136 bottom.

Steven Haywood: 20 bottom, 21 both.

Legendary/Alex Bailey: 116 bottom.

Lucasfilm Ltd: 7, 130 bottom.

Ryan McNamara & Channel 4 TV: 127 both.

Joe McNeilage: 42, 44 middle.

Mammoth Screen Limited: 11, 12, 15 top, 33 both, 34 top.

Simon Mein/Thin Man Films: 86 both.

National Trust: 54 bottom, 90 top.
National Trust Images/Mark Bolton: 37.
National Trust Images/Andrew Butler: 18 top, 20 top, 28 top, 56, 66, 69 top, 72, 76, 88, 93, 117 top, 131 top, 133 top, 138, 132 top.

National Trust Images/Joe Cornish: 145.
National Trust Images/Derek Croucher: 114 top.
National Trust Images/James Dobson: 2, 59 top, 60, 89 top right, 89 bottom, 90 middle and bottom, 91 both, 116 top.
National Trust Images/Andreas von Einsiedel: 115.
National Trust Images/Christopher Gallagher: 148 bottom.
National Trust Images/Kirsty Gibbons: 92 top.
National Trust Images/John Hammond: 67 top, 102 middle, 105.
National Trust/Paul Harris: 124, 128, 144 top.
National Trust Images/Tamsin Holmes: 51.
National Trust Images/Chris Lacey: 14 top, 17, 25 both, 26 bottom, 53 top, 59 bottom, 126.
National Trust Images/Marianne Majerus: 13 top.
National Trust Images/Nick Meers: 120, 147.
National Trust Images/John Millar: 112 top, 130 top, 141 top, 149 top.
National Trust Images/John Miller: 31, 83 top, 85, 101, 142.
National Trust Images/Robert Morris: 24, 95 bottom, 149 bottom.
National Trust Images/Richard Scott: 110.
National Trust Images/David Sellman: 10.
National Trust Images/Arnhel de Serra: 58, 100 top, 122, 143 bottom.
National Trust Images/Steve Stephens: 29 top.
National Trust Images/Megan Taylor: 95 bottom, 96 all three, 97 bottom.
National Trust Images/Rupert Truman: 22.

Netflix: 118, 119 all three.
Netflix/Colin Hutton: 65 top.
Netflix/Liam Daniel: front cover top, 65 bottom, 71, 87, 92 bottom.

Leanne Newman: 102 bottom.

Philip Ramey Photography, LLC: 136 bottom.

Jake Sainsbury: 30.

See-Saw Films: 100 bottom.

Shutterstock: front cover bottom, 14 bottom, 15 bottom, 18 bottom, 19 both, 27, 31 bottom, 35 both, 40 both, 41, 54 top, 57, 67 middle and bottom, 70, 75, 79, 80 both, 81, 82 top, 83 bottom, 94, 97 top, 98, 99, 102 top, 103, 104, 107, 109 bottom, 112 bottom, 113 both, 123 both, 125 bottom, 129, 131 bottom, 133 bottom, 137, 141 bottom, 146 top, 148 top.

2020 STUDIOCANAL S.A.S., All Rights Reserved: 132 both, 143 top.

Alexandra Tandy: 68 top.

Lauren Taylor: 44 top and bottom, 106 middle and bottom.

2010 Twentieth Century Fox: 106 top.
2015 Twentieth Century Fox: 73 both, 74 both.

Universal Images: 61 all four.
2010 Universal Pictures: back cover.
2012 Universal Studios: 84 both.
2015 Universal Studios and Amblin Entertainment, Inc: 134 both.
2008 Universal Studios and Internationale Filmproduktin Eagle Filmproduktions-gesellschaft mbh & Co. KG: 121.

Nick White: 62 all three.

Des Willie: 69 bottom.

Maps on pages 6, 43 and 77: Sudden Impact Media Ltd.

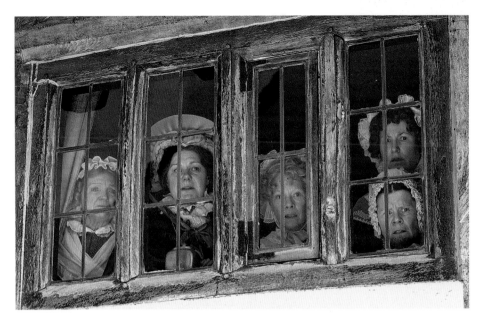

ABOVE Cranford's ladies keep an eye on Lacock Village in Wiltshire.

ACKNOWLEDGEMENTS

The authors would like to thank Siân Evans, Vicki Marsland, Sarah Payne, Sally Dracott, Simon Ford, Emma Clarke-Bolton, Sally Doran, Robert Floyd, Patsy Floyd, Charlotte Haydon, Leanne Newman, Robert Adam, all toads real and fake.